500 Flowers

First published in the UK in 2005 by
Dewi Lewis Media Ltd, 8 Broomfield Road
Heaton Moor, Stockport SK4 4ND
+44 (0)161 442 9450

www.dewilewismedia.com

For the photographs and texts: Roger Camp
For this edition: Dewi Lewis Media Ltd

ISBN: 0-9546843-4-6

Design & artwork production: Roger Camp & Dewi Lewis
Print: EBS, Verona

d

500 FLOWERS

Roger Camp

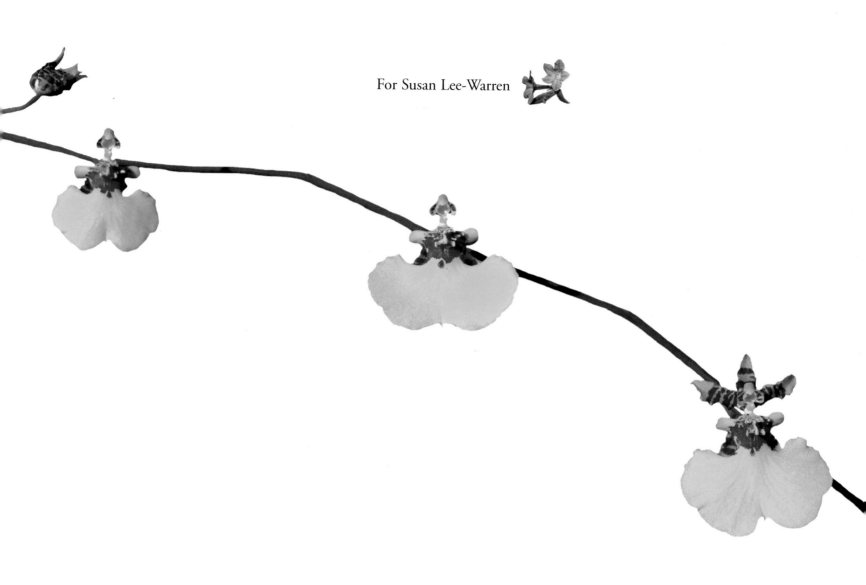

For Susan Lee-Warren

My love affair with plants began as a child. My mother introduced me to flowers and my father taught me to grow vegetables. Our home was located on the city limits of Orange, California, in the heart of a citrus producing region. An orange grove, which began at the end of our street and extended for miles in three directions, was my playground. Even today, the scent of orange blossom evokes strong memories of long, idle, summer days spent exploring and assimilating the colours, patterns and scents of my childhood.

Our yard was filled with a variety of flowers and fruit trees. Occasionally my mother would send me into the garden to pick a bouquet of flowers. While my choices were limited by what was in bloom, my selections were determined by the size, shape, texture, colour and sometimes fragrance of the flowers, as well as the overall relationship of the plants when presented as a whole. I took this task seriously. Once my mother had me enter one of my bouquets into the children's division of the flower arranging competition held annually by the local Women's Club. It was awarded a ribbon and I suspect this experience helped to cement the idea that flowers could provide the subject matter for artistic pursuits.

My mother made it a point to take my brother and I regularly to the art museums in our area. She passed on her love of the work of the impressionist and post-impressionist painters, many of whom not only painted flowers but were serious gardeners as well. She took to wearing an hibiscus blossom in her hair much like one of Gauguin's vahines. Not only did this add to her already exotic appearance, but it also gave rise to her family nickname 'Lotus Blossom', which reinforced in my mind that flowers could be used to add mystery and allure to the world.

This book grew directly from my previous book, *Butterflies in Flight*, the transition from butterflies to flowers being natural indeed. Both books have provided me with the opportunity to immerse myself in the rhythms of the natural world and to encompass nature's designs within my own as an artist. Living in the mediterranean climate of Southern California has given me access to plants that originate from all over the world. Over the last three years, whenever I saw a flower that interested me I would attempt to purchase and grow it myself. As a result, more than half of the flowers in this book come from my own garden. The remainder were photographed digitally in various botanical gardens in Southern California,

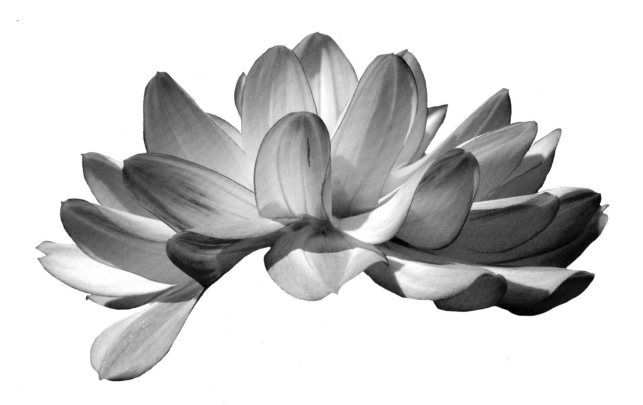

including the California native plant garden located on the campus of Golden West College where I teach. The rest came from the gardens of friends and, in some cases, the front yards of my neighbours in Seal Beach where I live. One aspect of using flowers as subject matter is that one learns quickly that the requirements of the artist are subject to the vagaries of nature. In some instances I had to wait two years for a plant to bloom, only to find I no longer had a use for that particular flower. Other plants died before fruition, making the decision of inclusion for me. Others far surpassed their representation in books, consequently providing me with possibilities beyond those I had initially imagined. Growing many of the flowers allowed me to study them at leisure as they matured.

Each page in this book was designed to stand alone, as well as to connect visually to both the preceding and following pages. Viewed this way, the entire book becomes a single extended still life as if it were a living garden one could stroll through. The resulting arrangement encompasses flowers from all seasons and geographical origins, making it possible to experience them simultaneously. For a moment, nature's design is subject to the design of the artist.

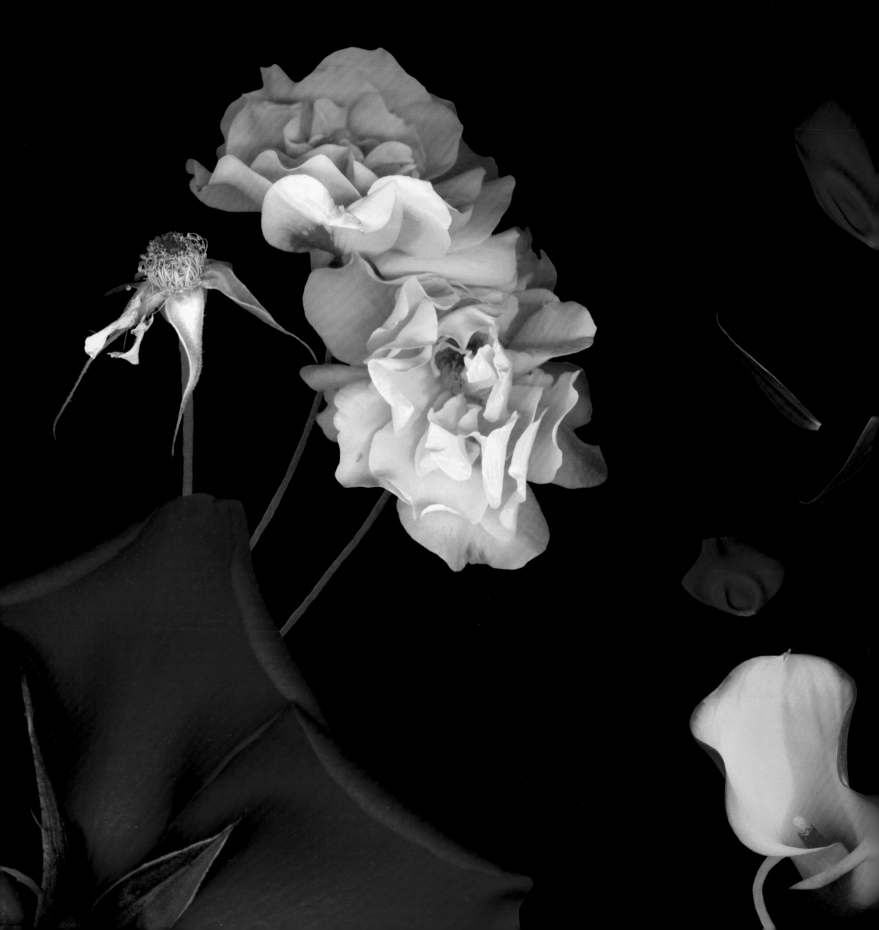

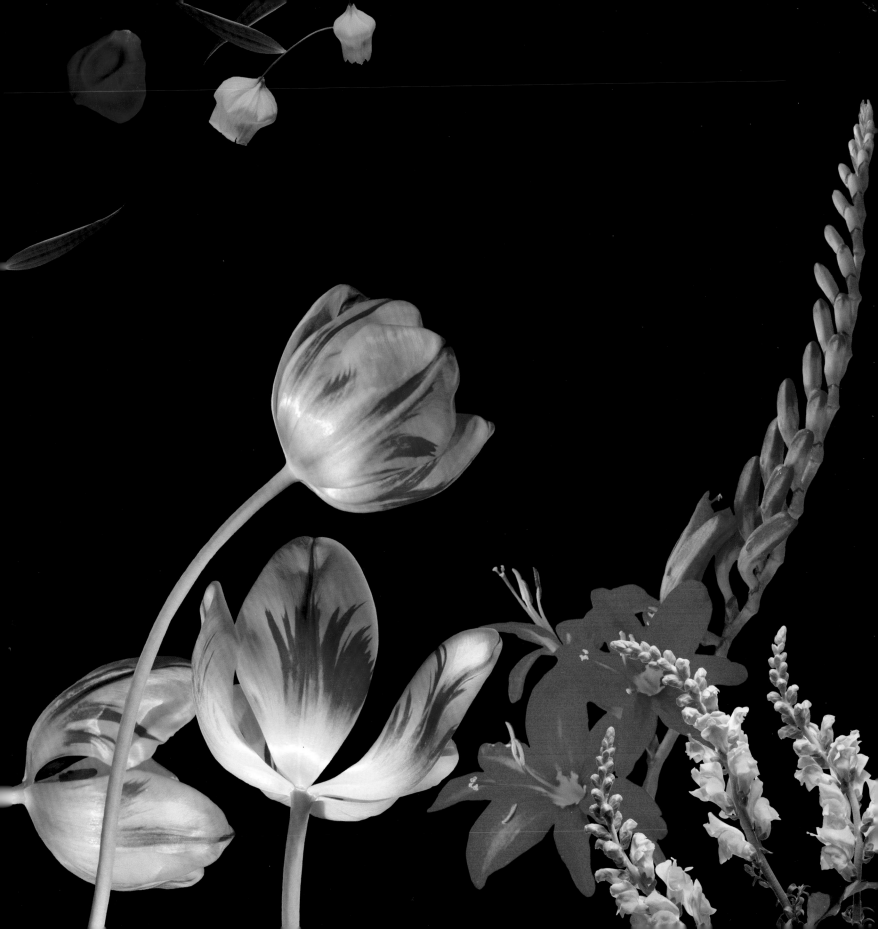

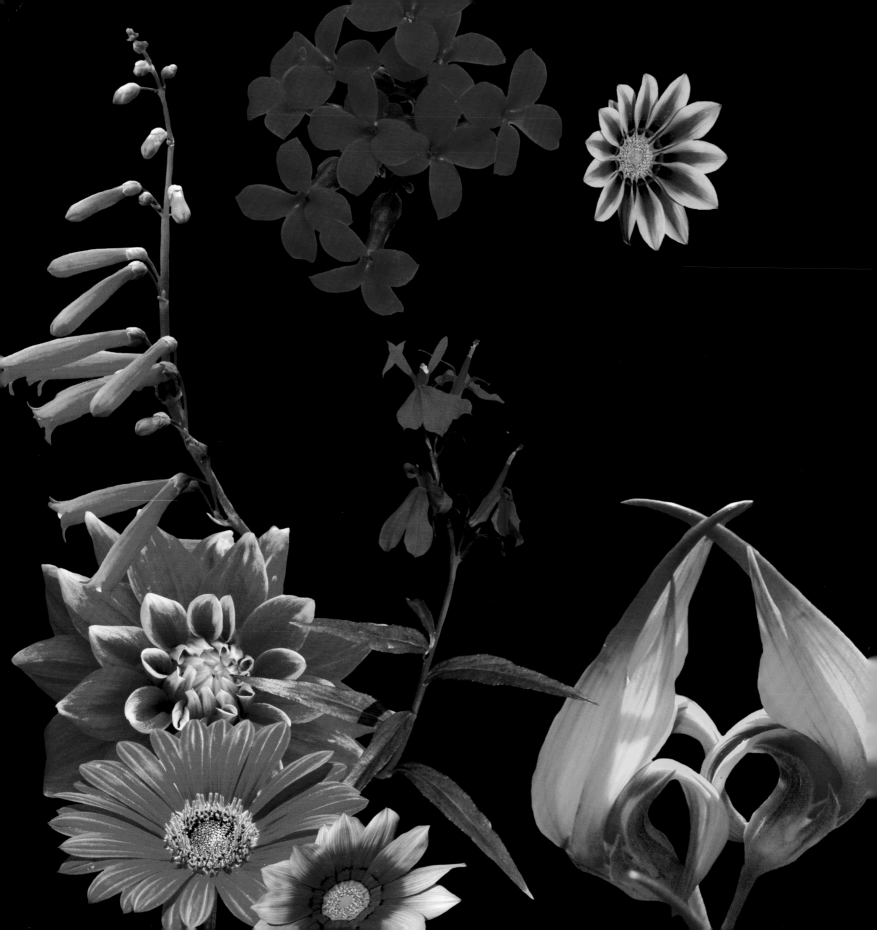

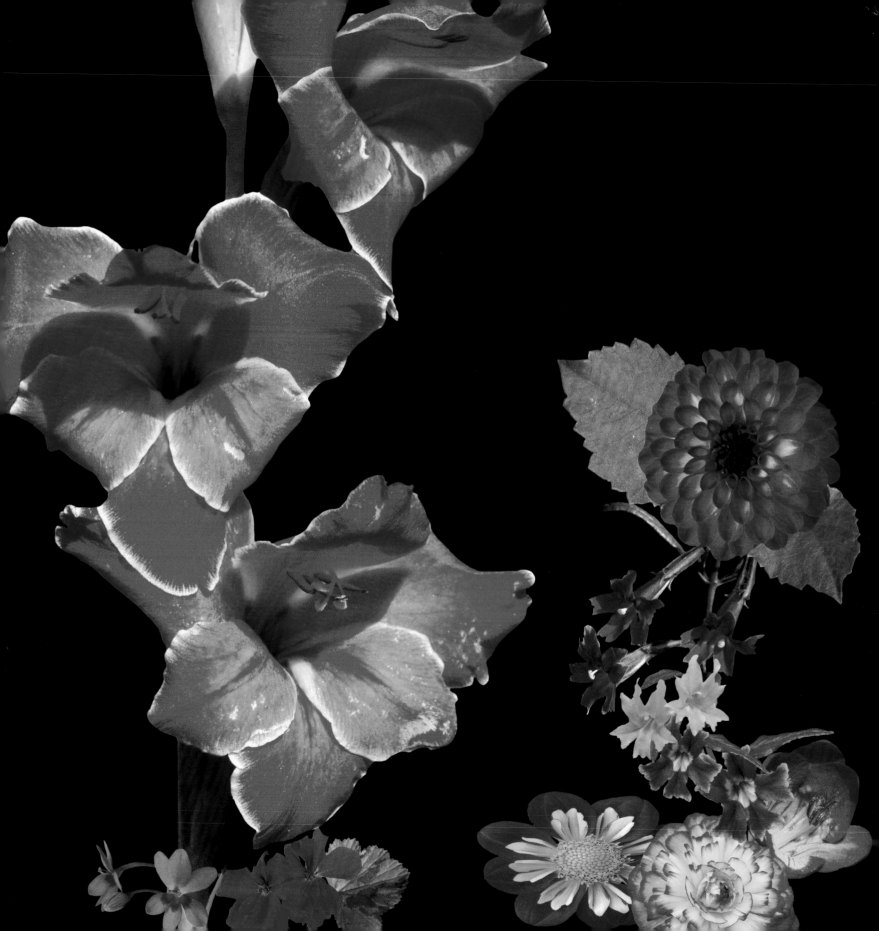

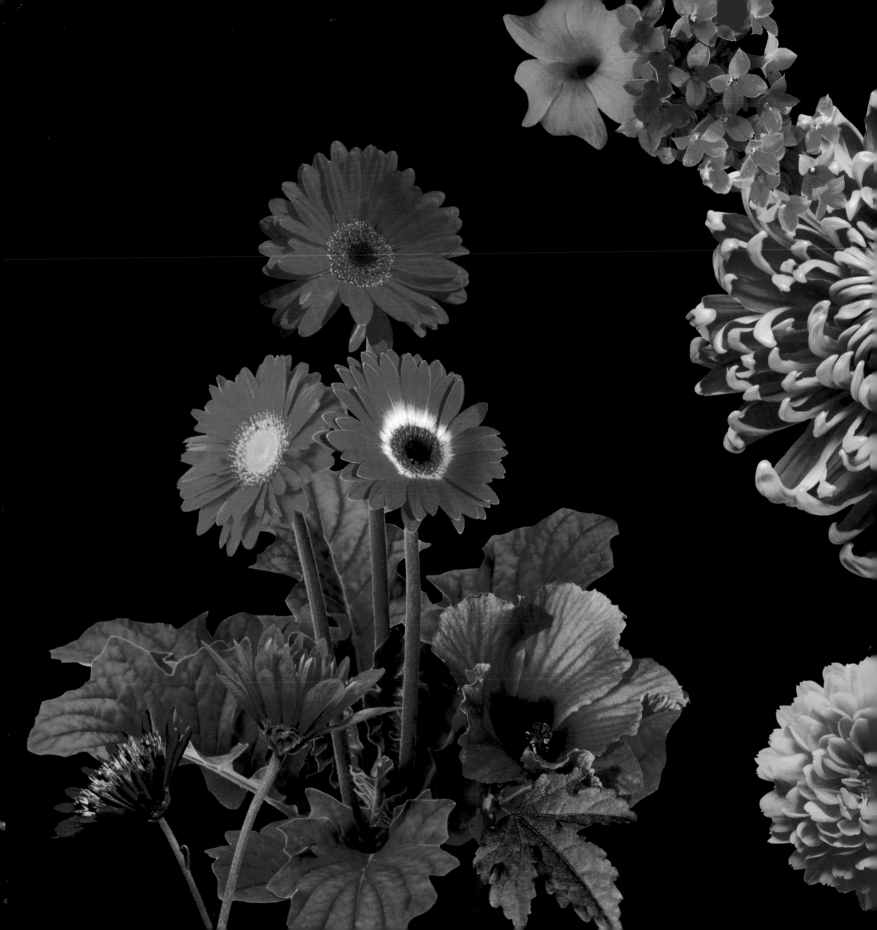

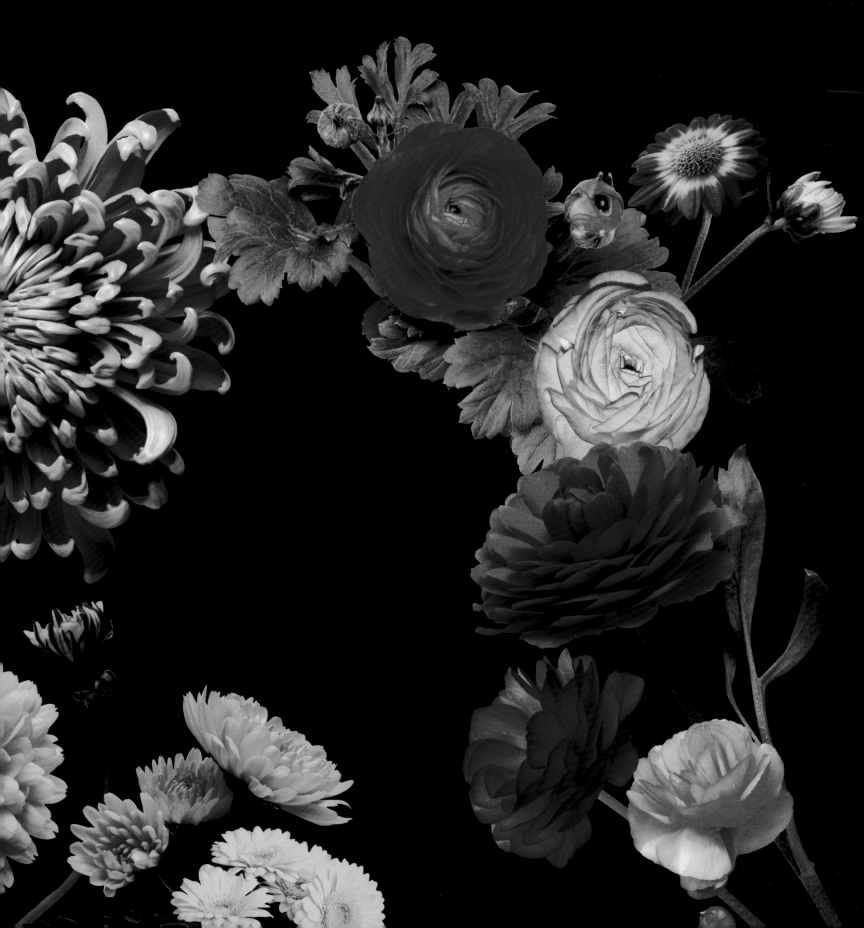

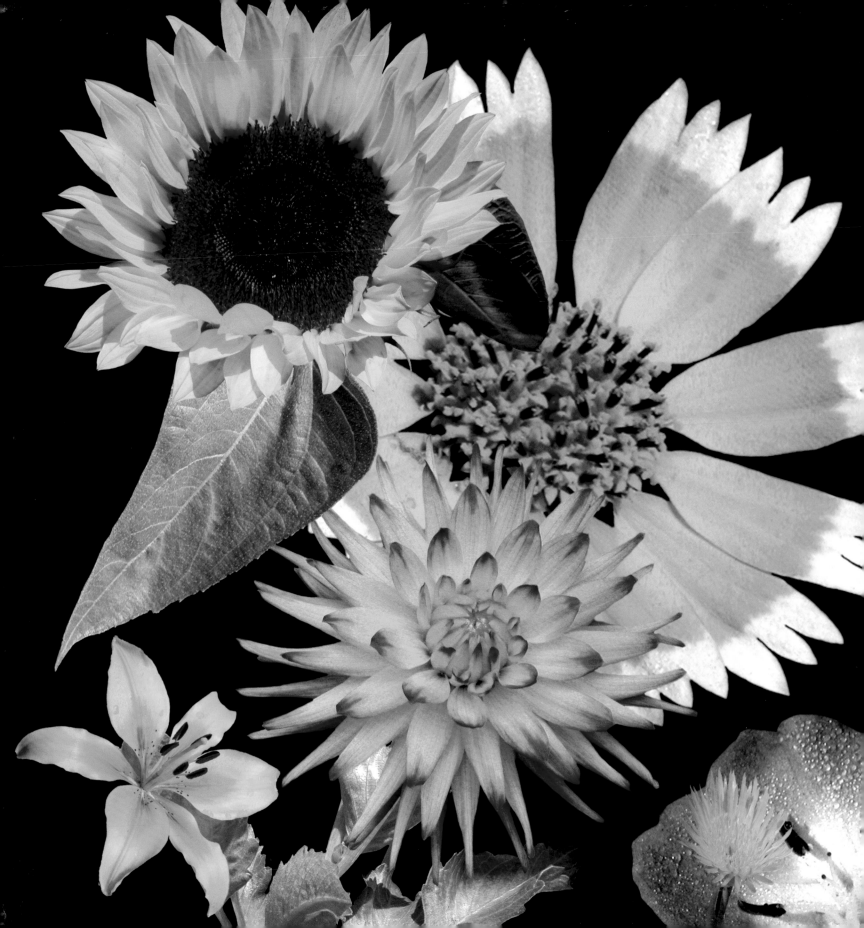

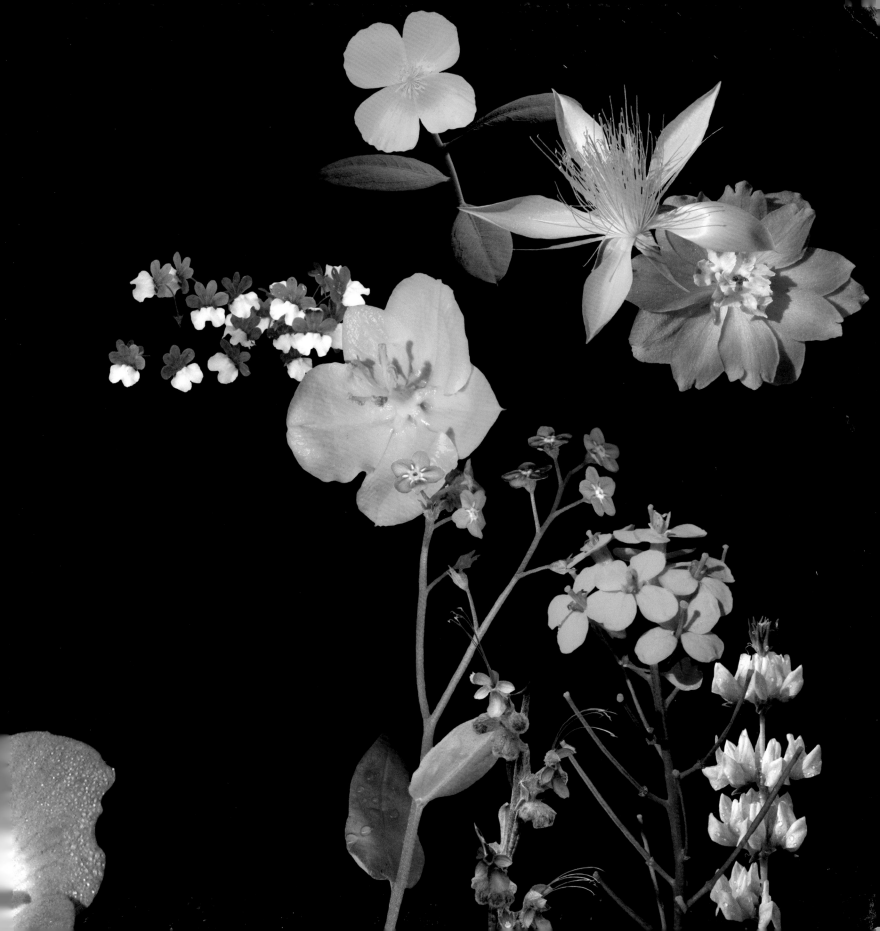

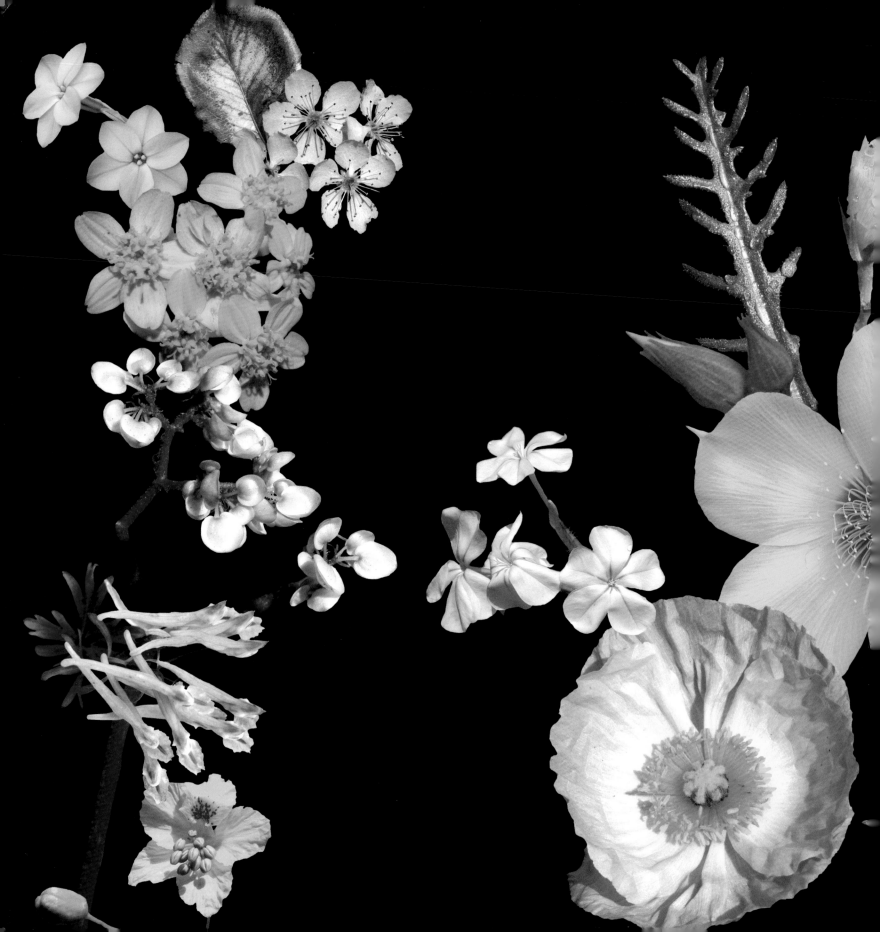

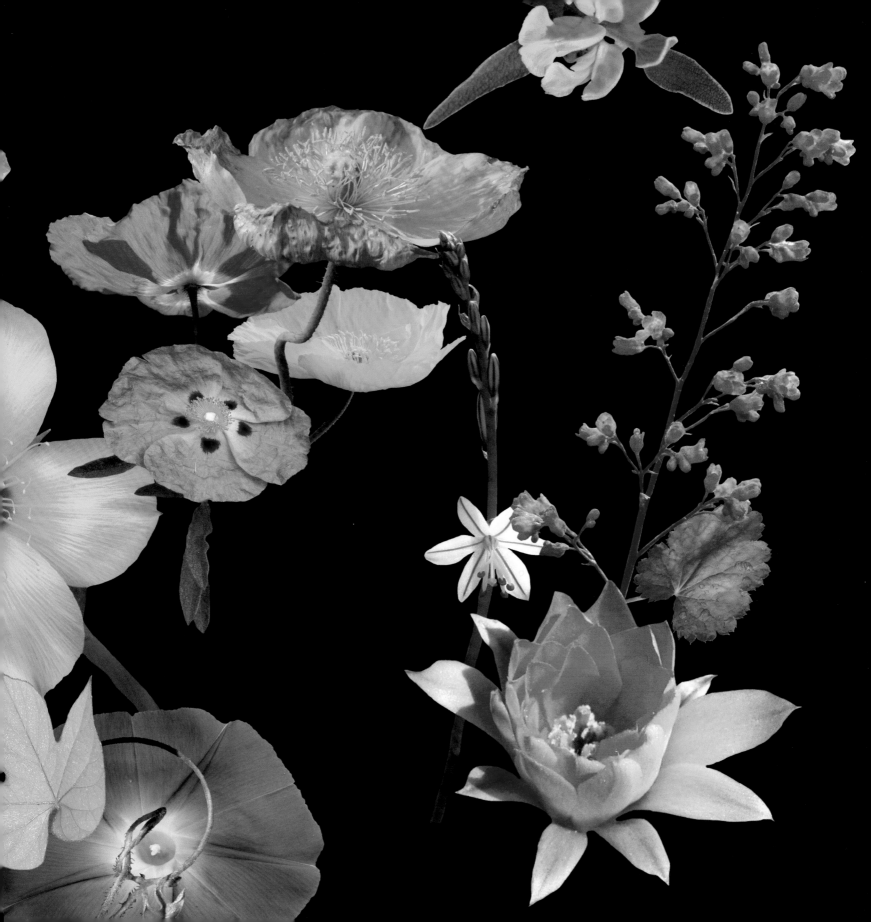

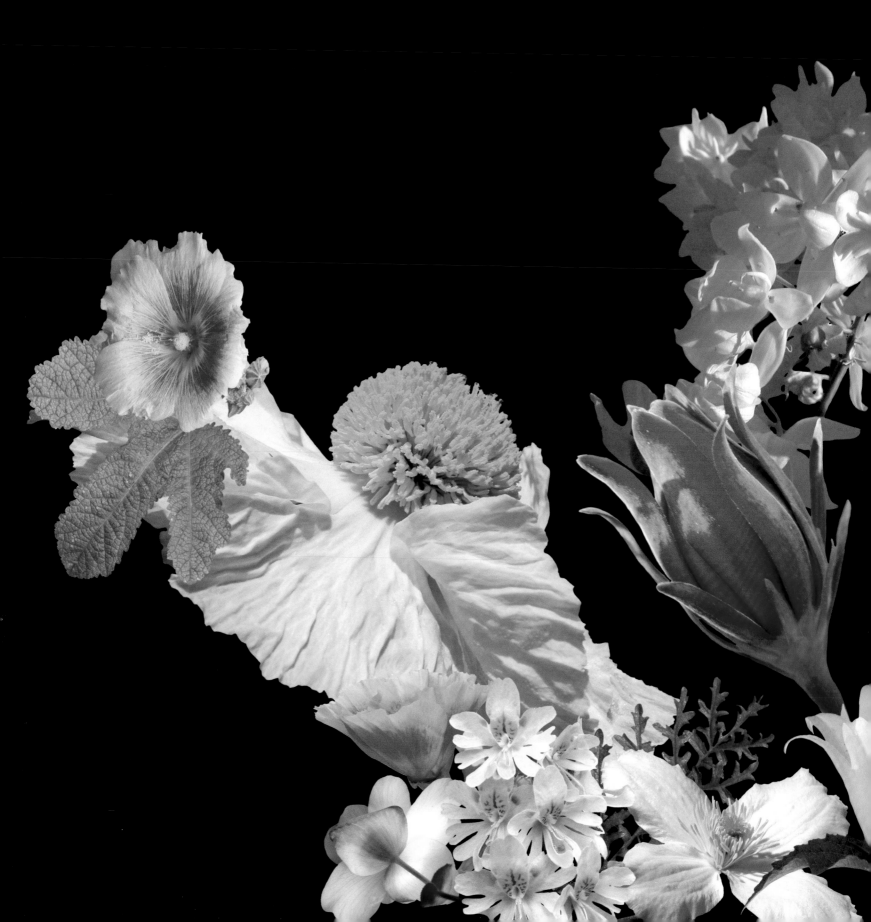

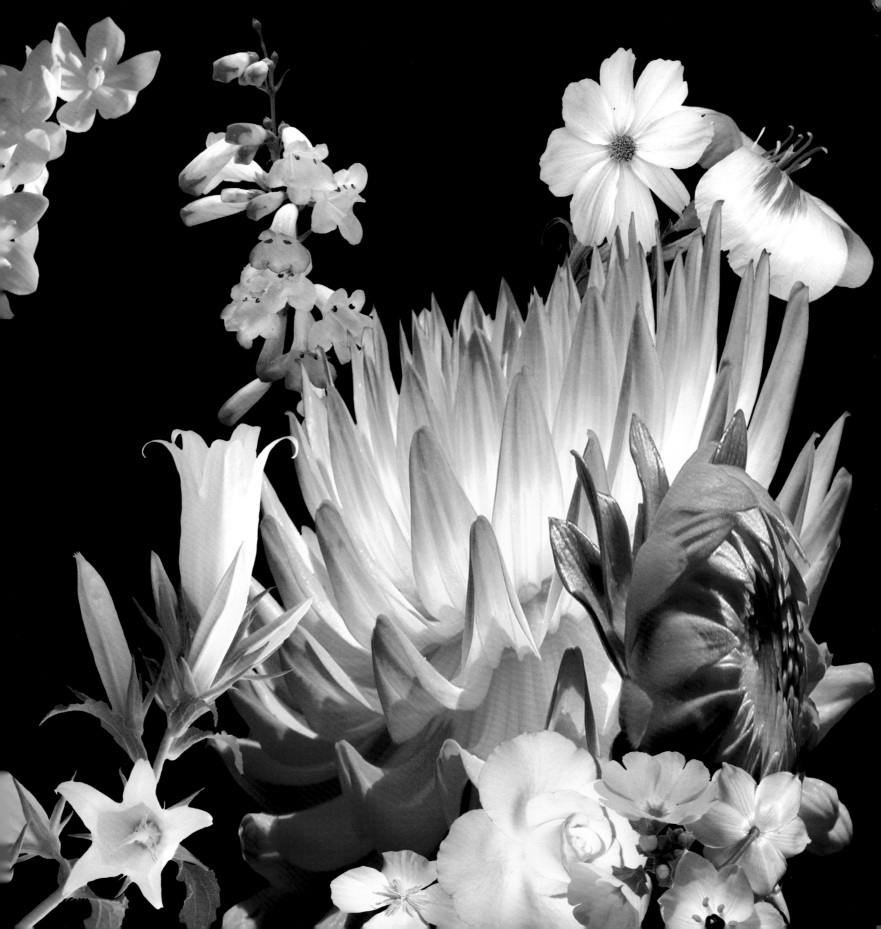

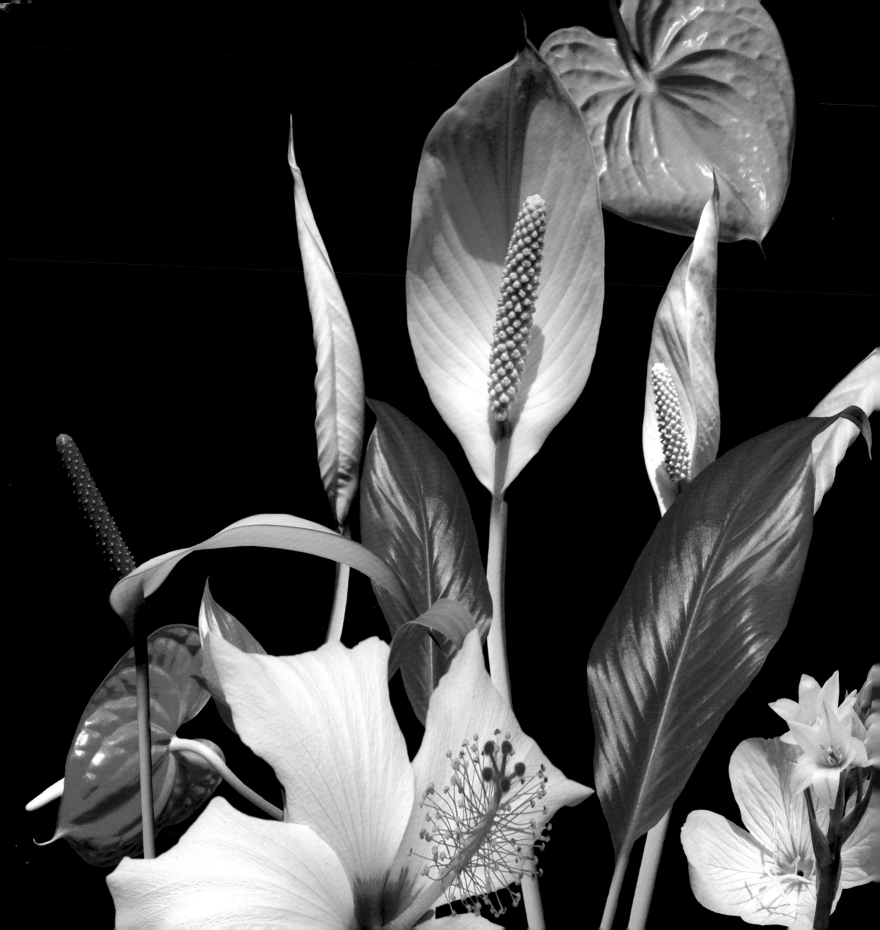

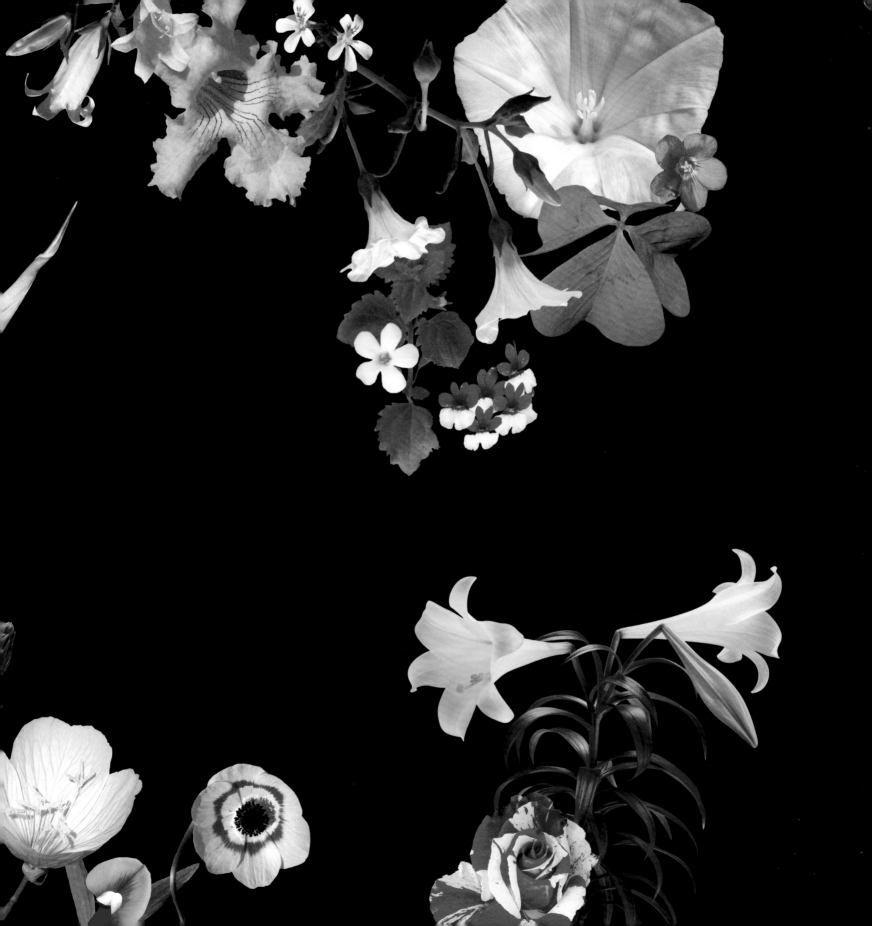

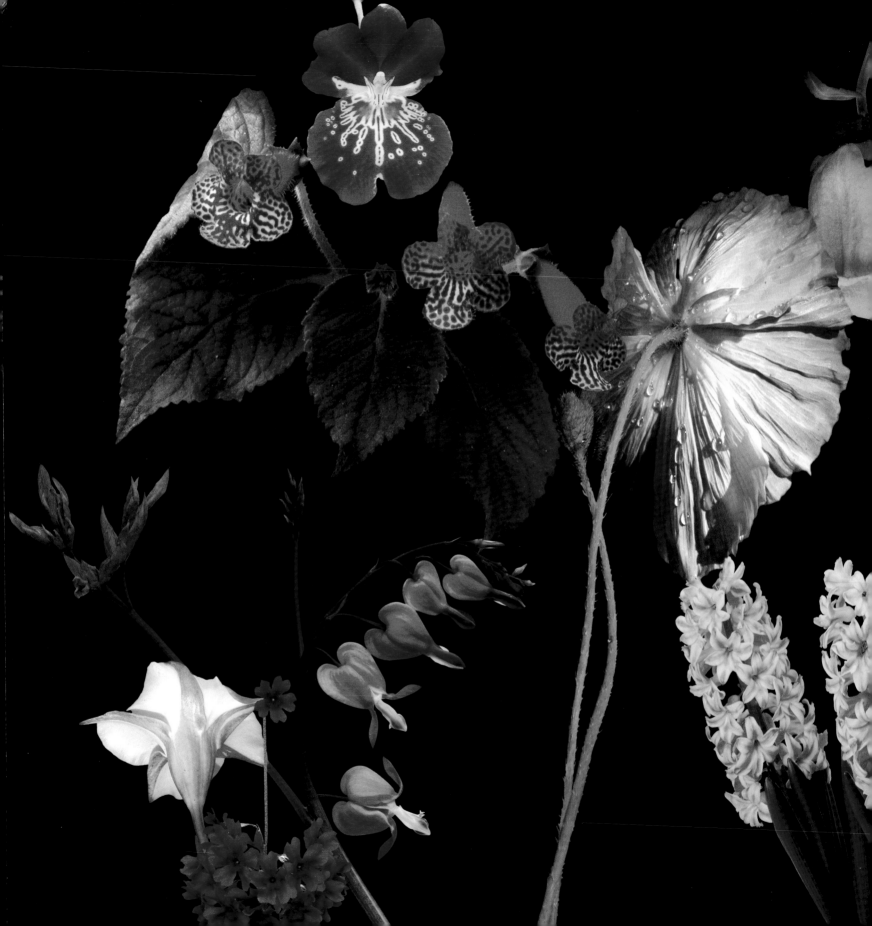

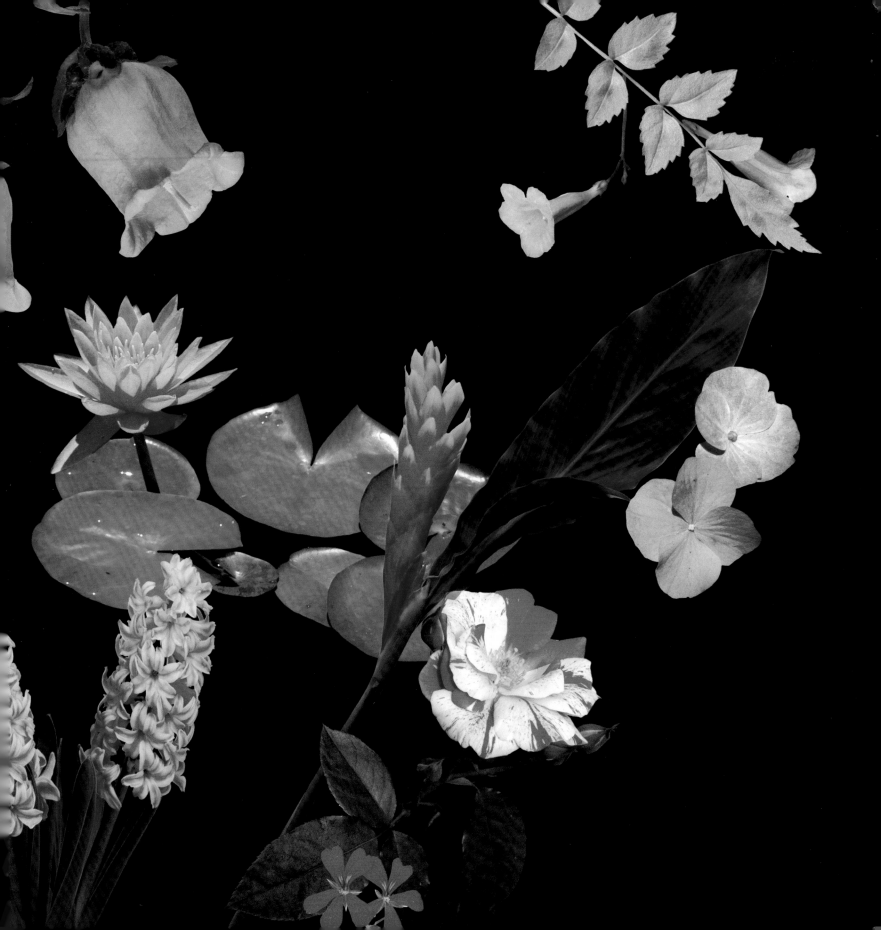

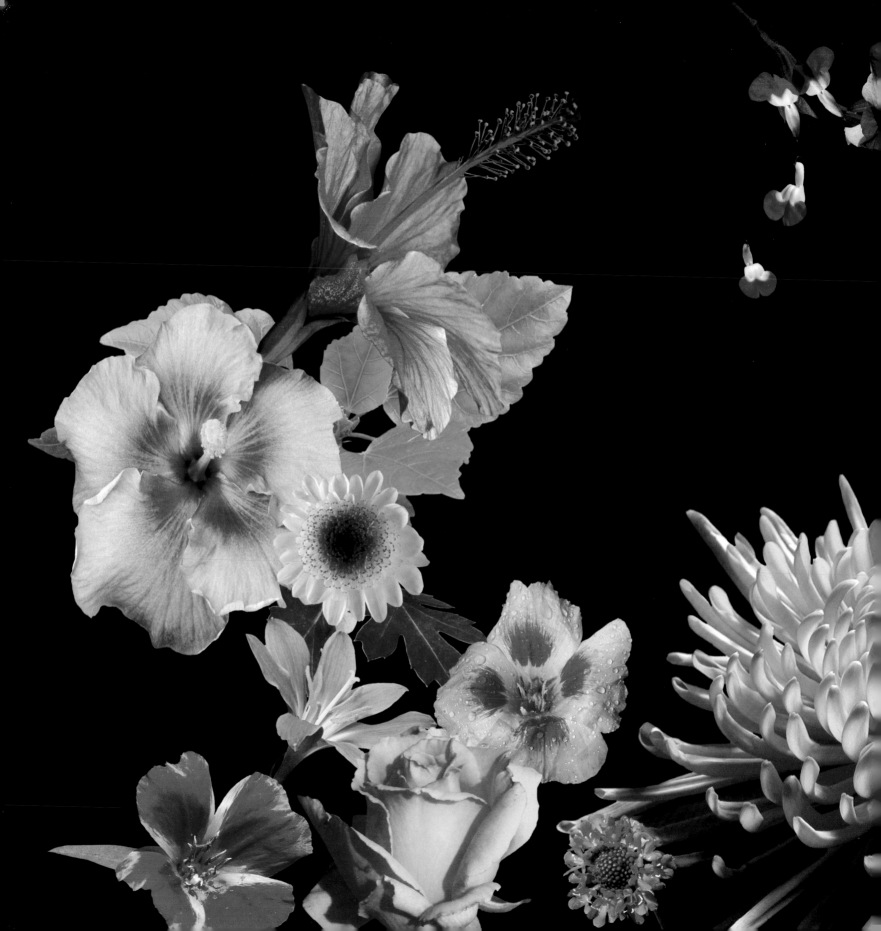

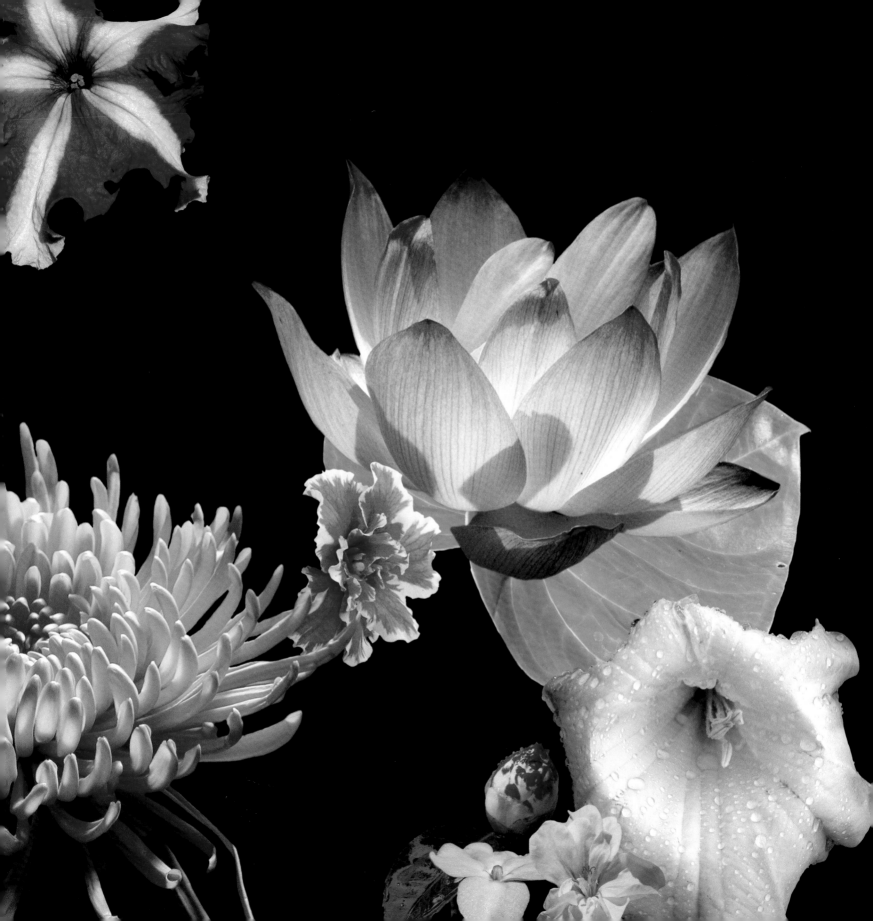

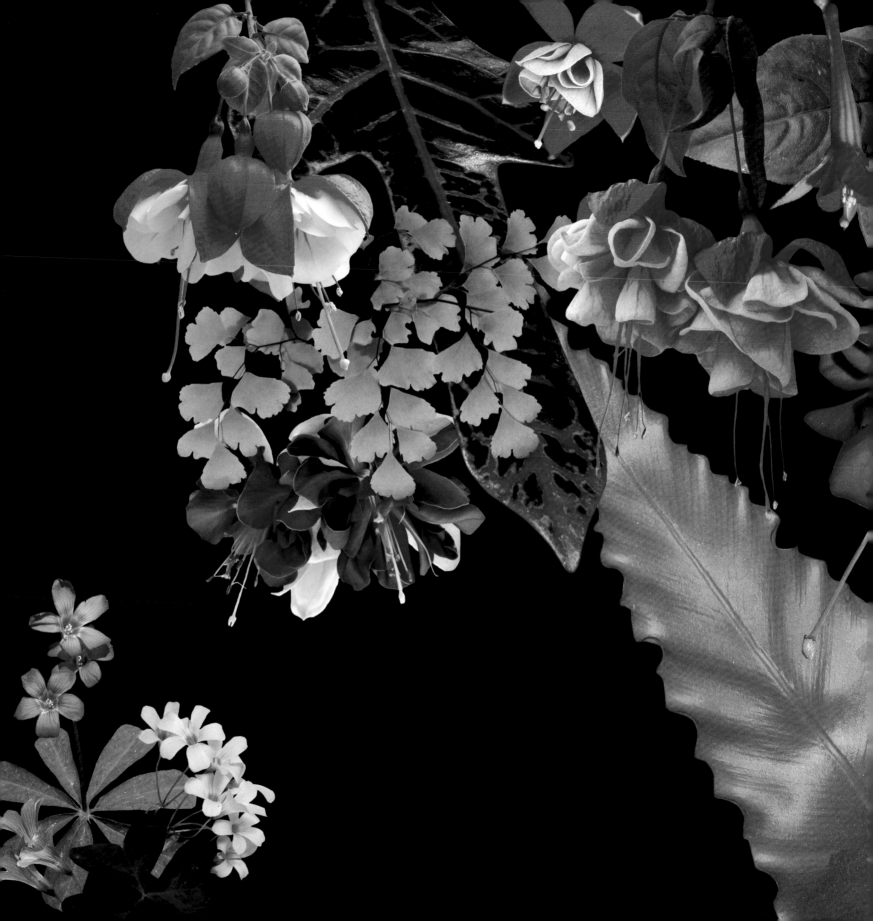

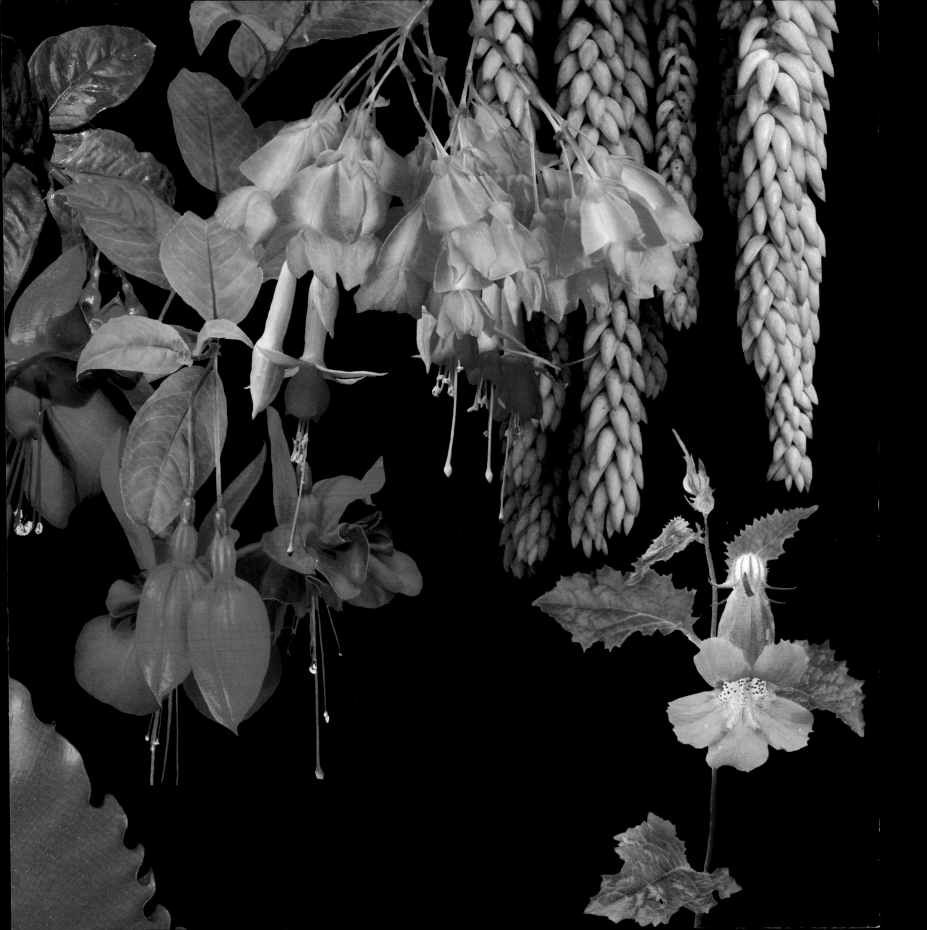

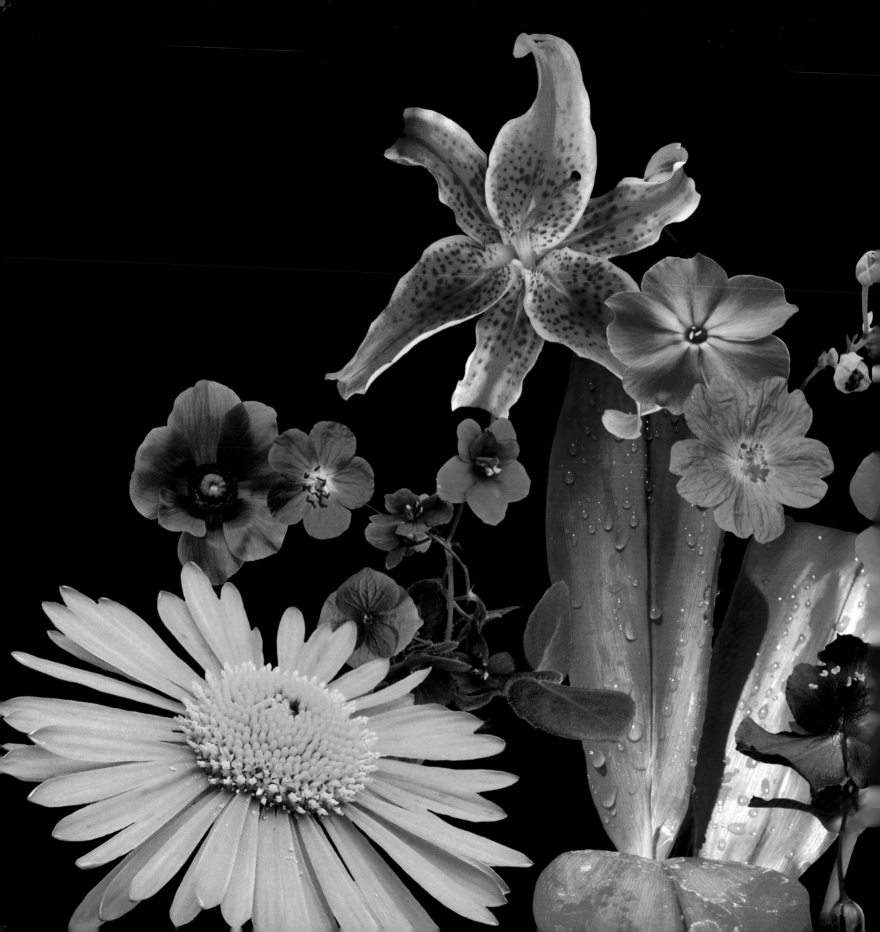

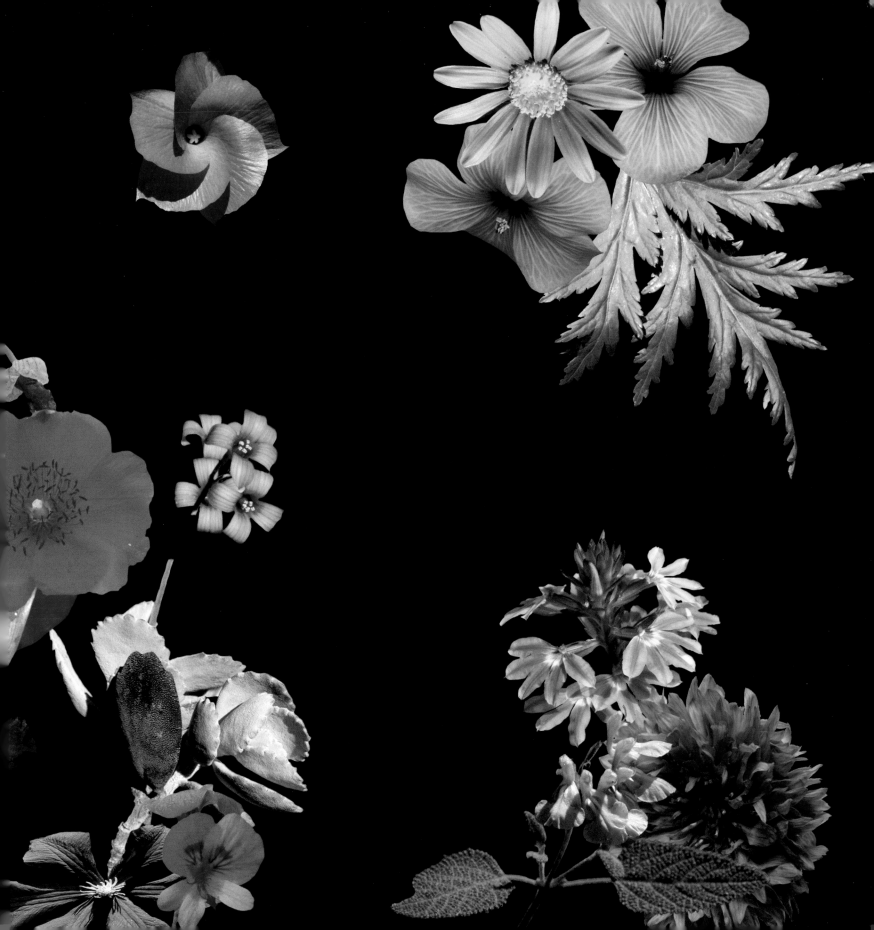

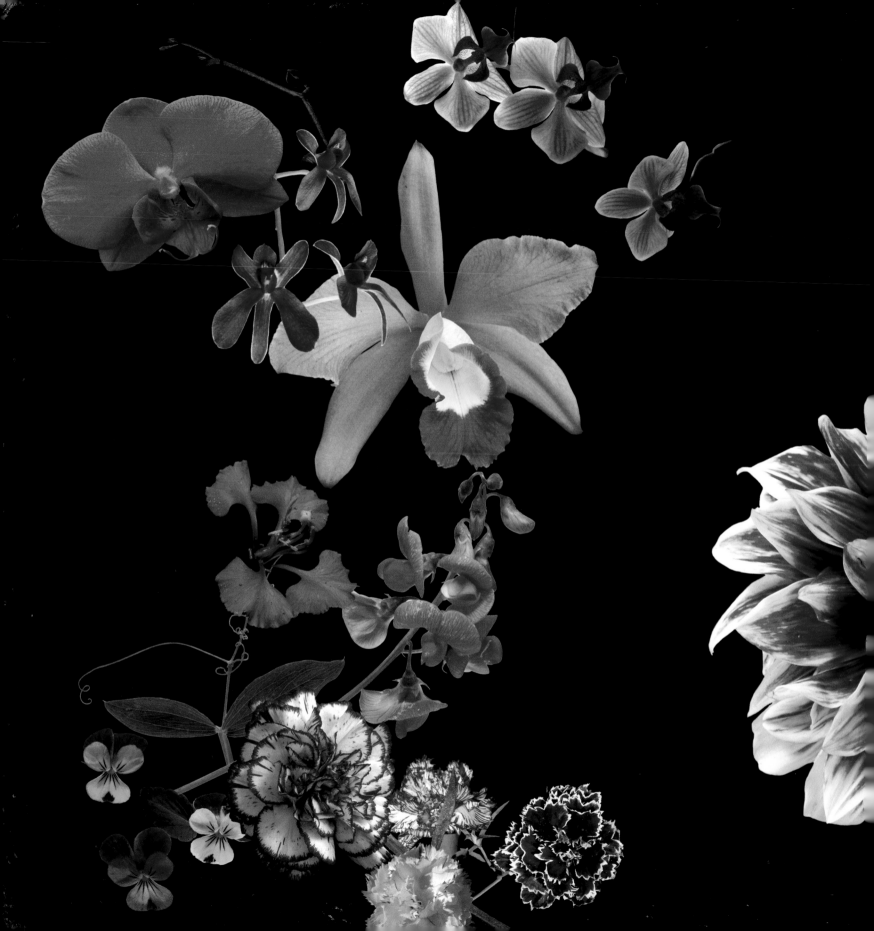

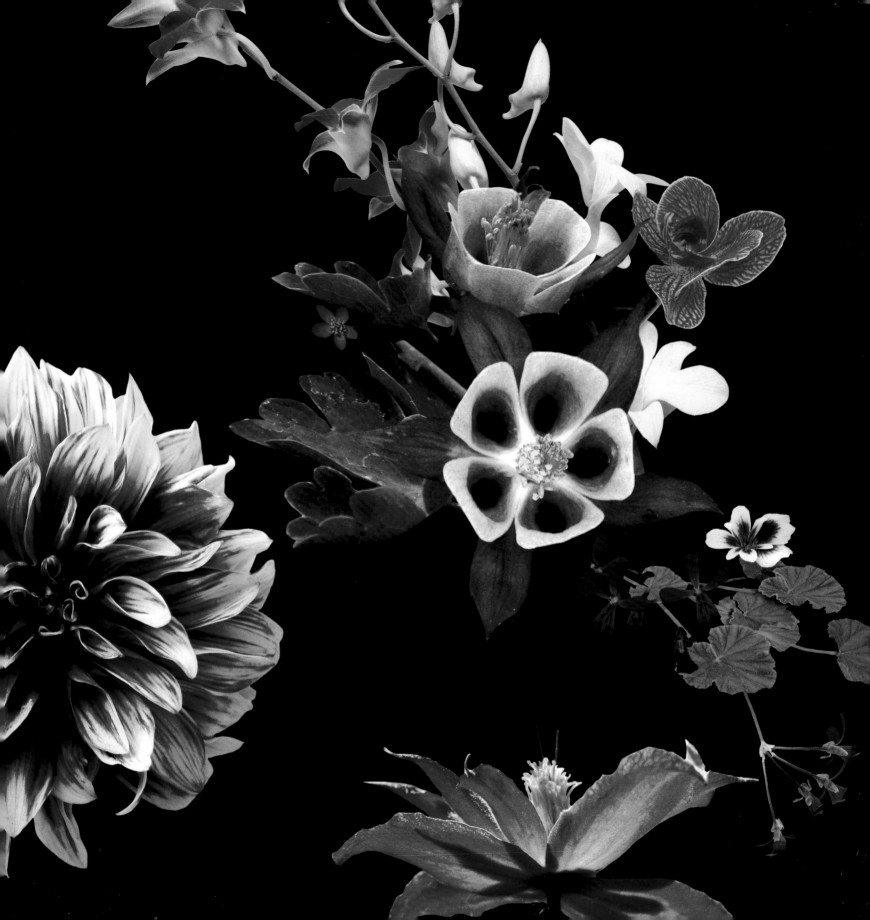

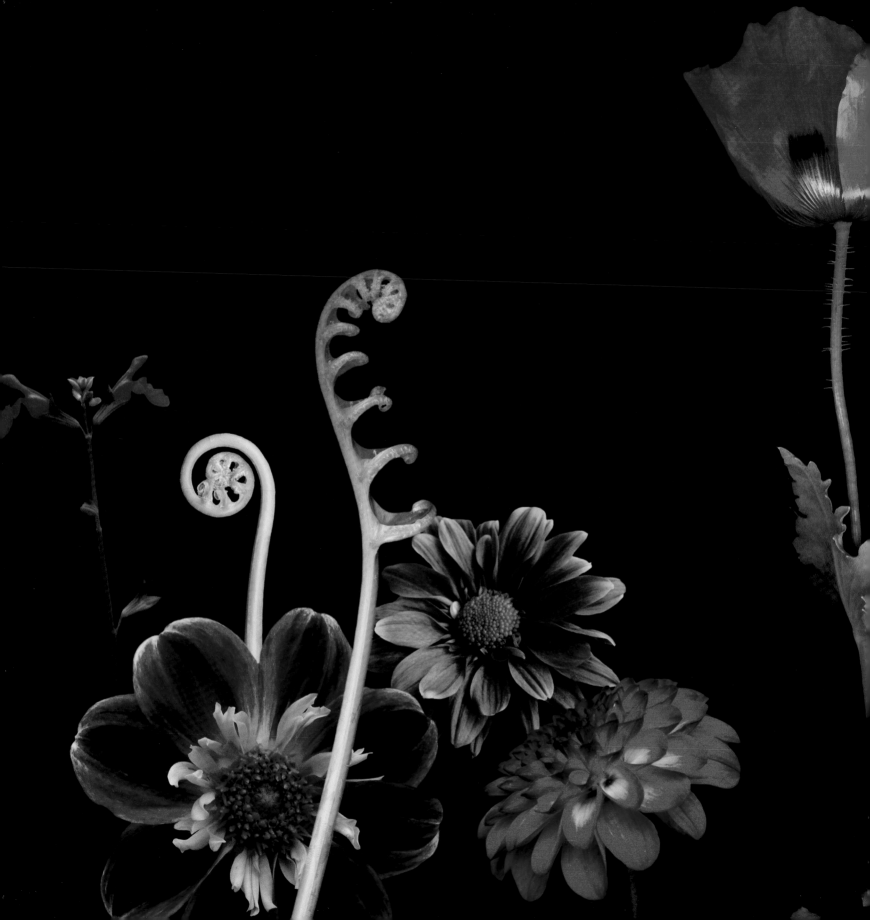

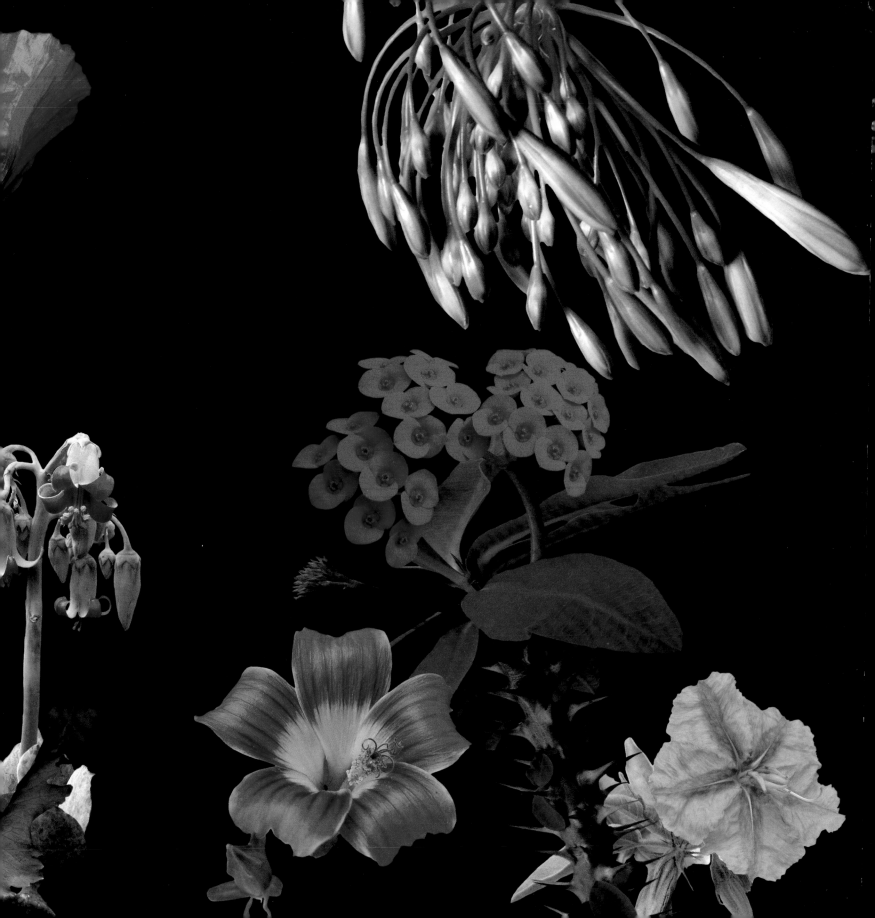

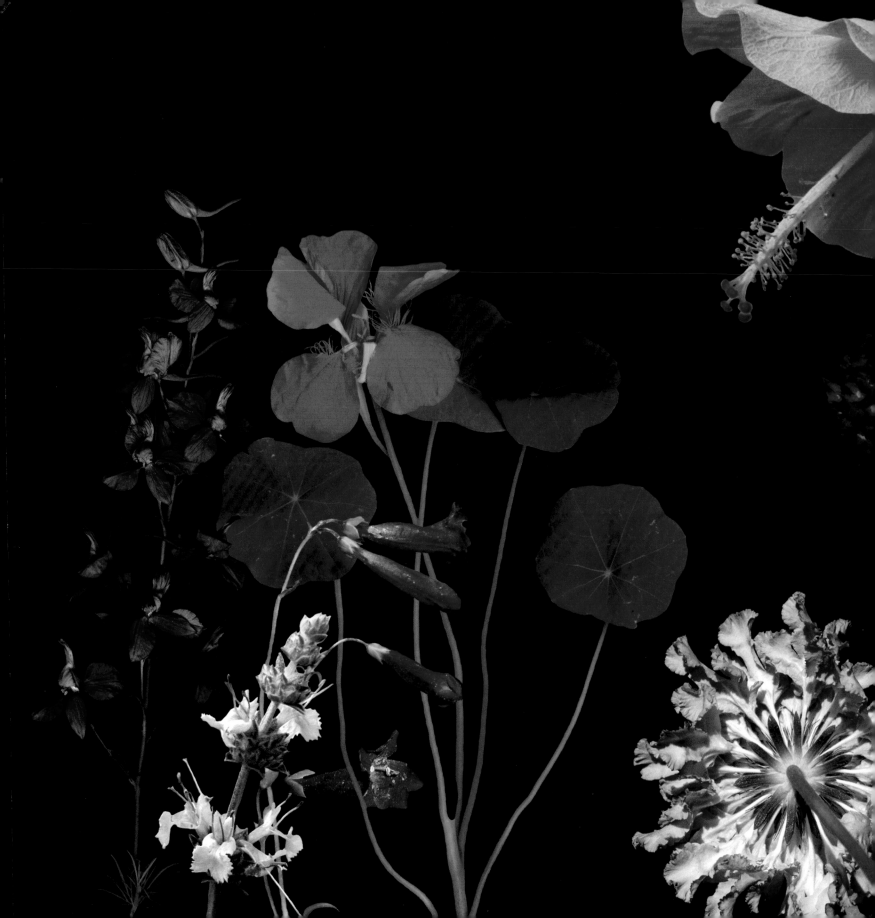

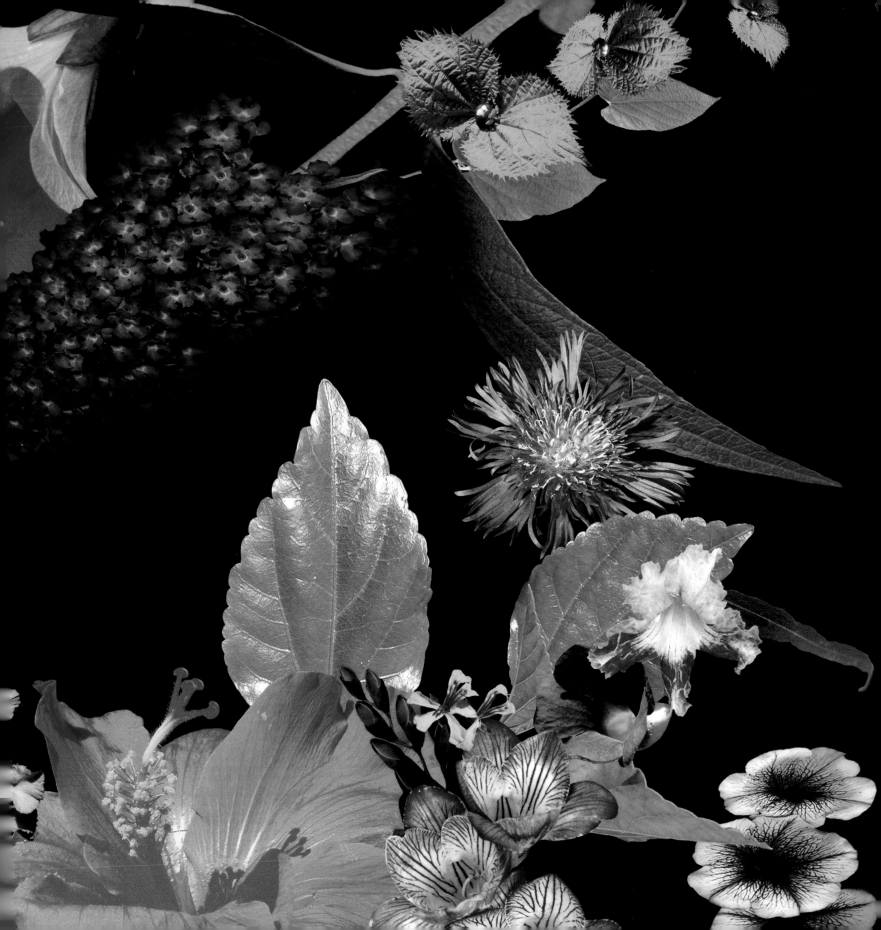

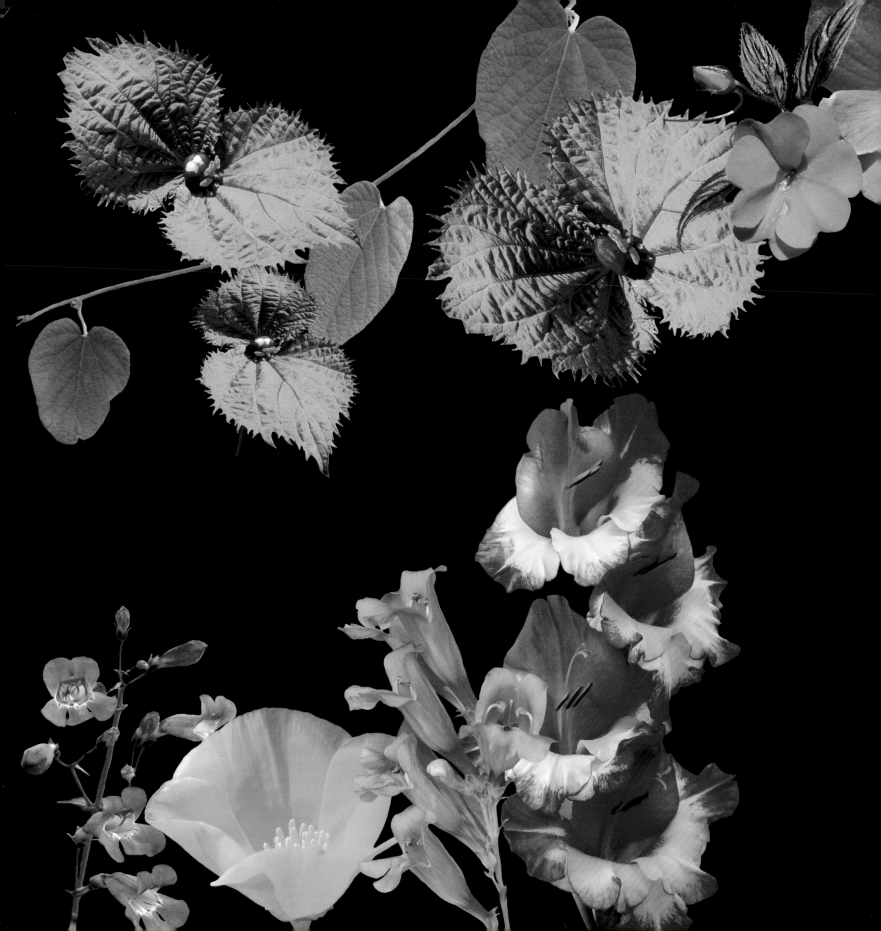

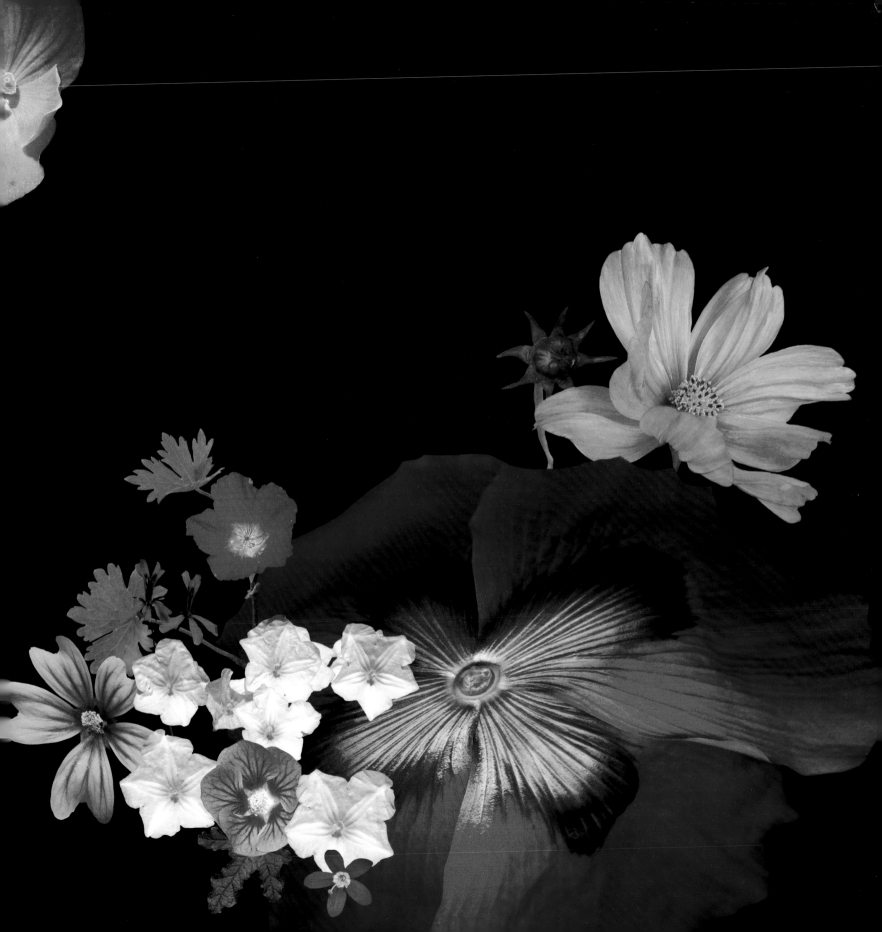

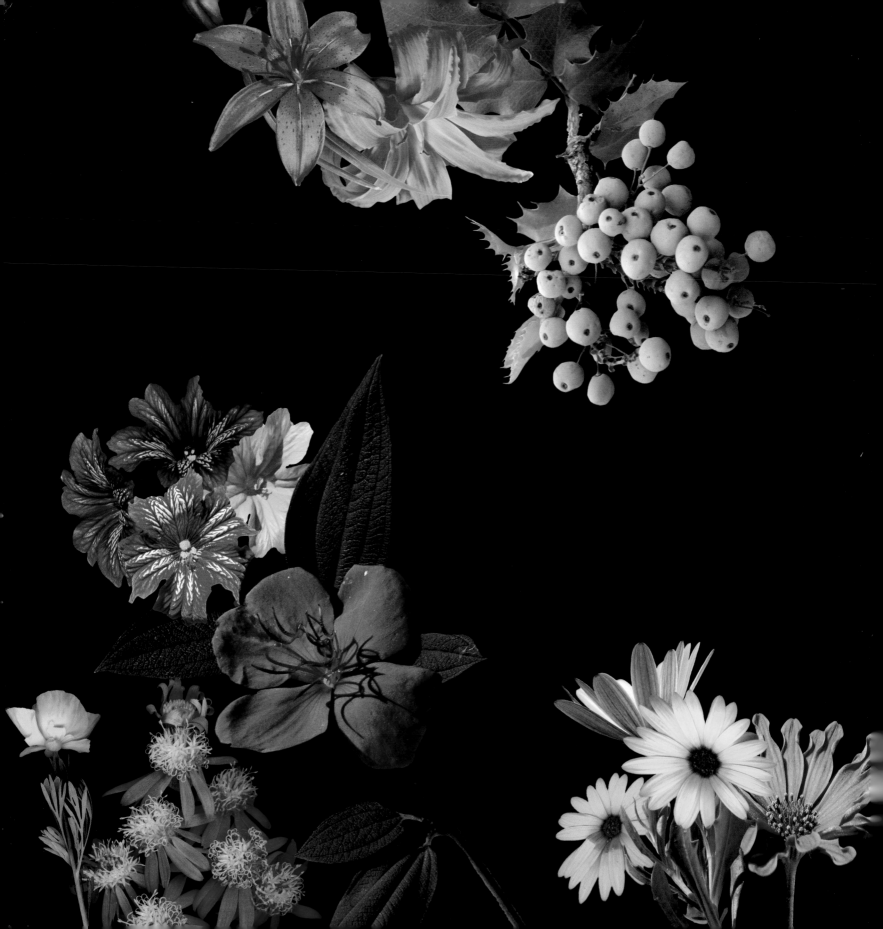

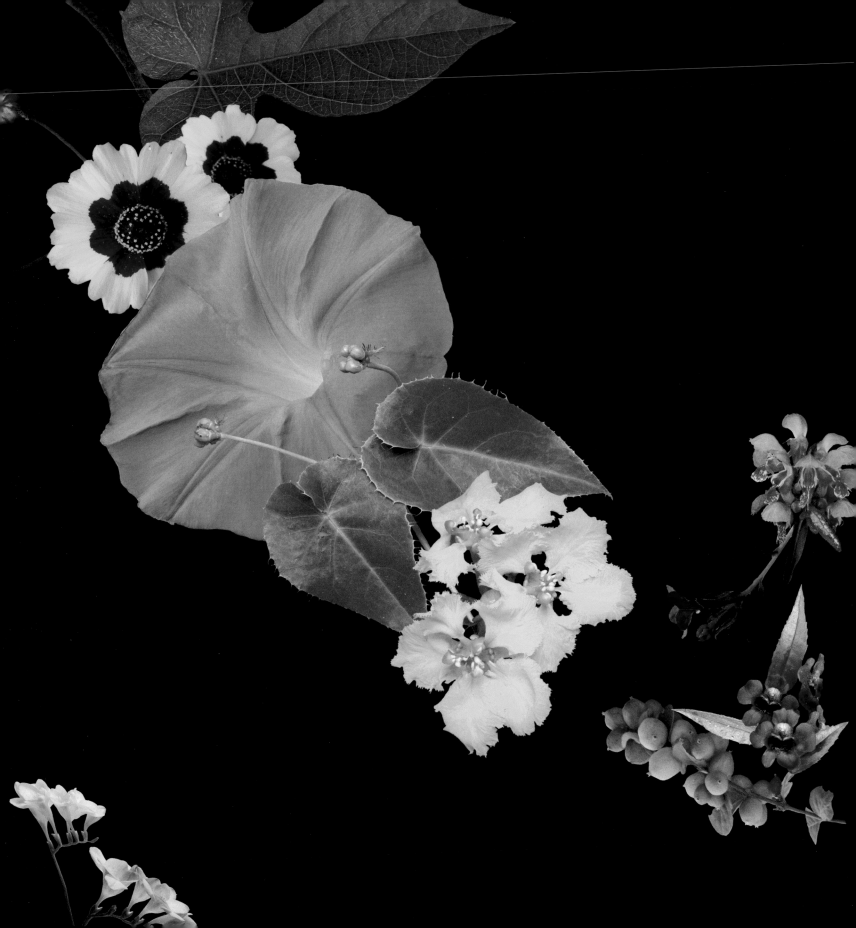

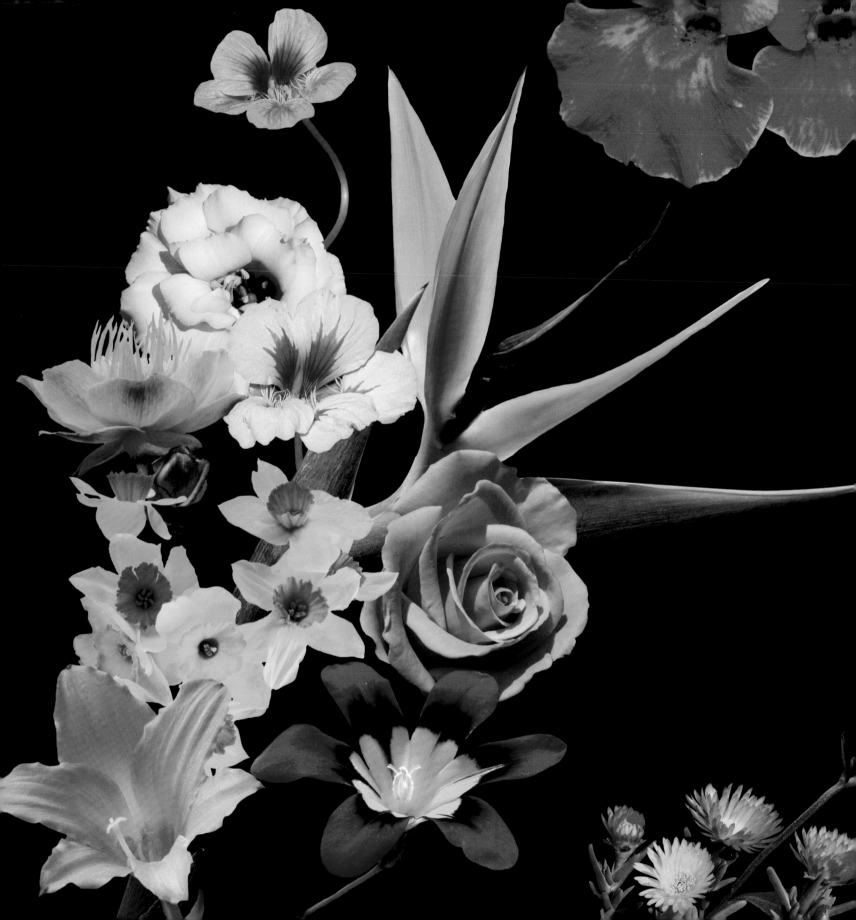

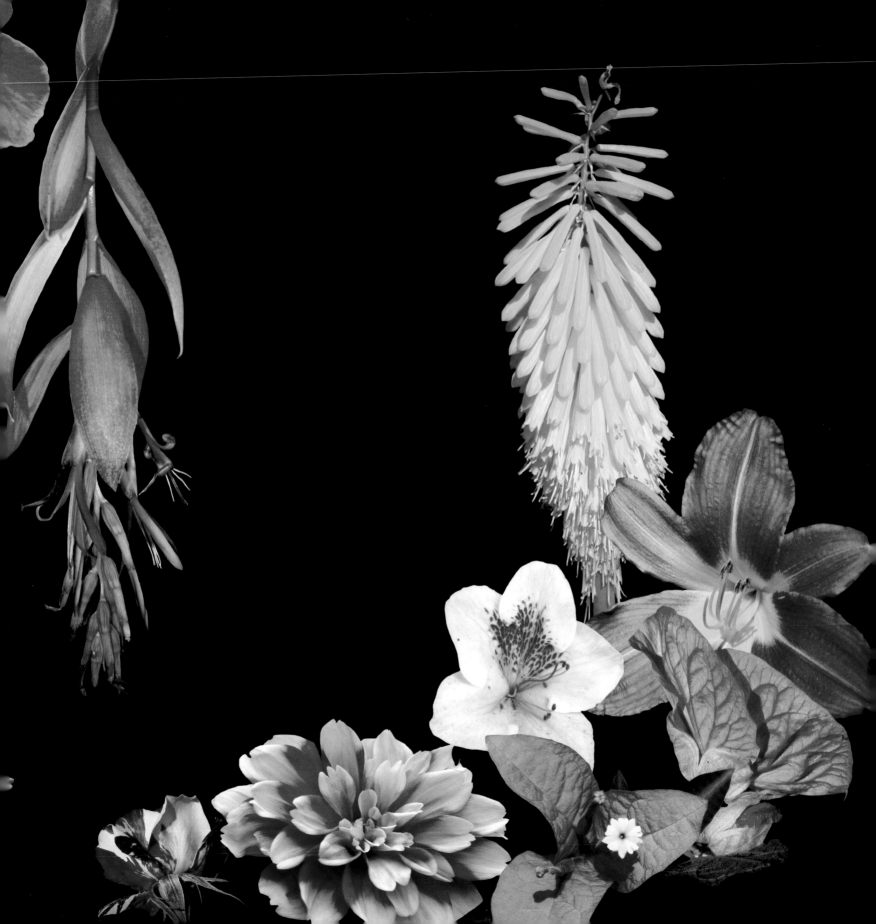

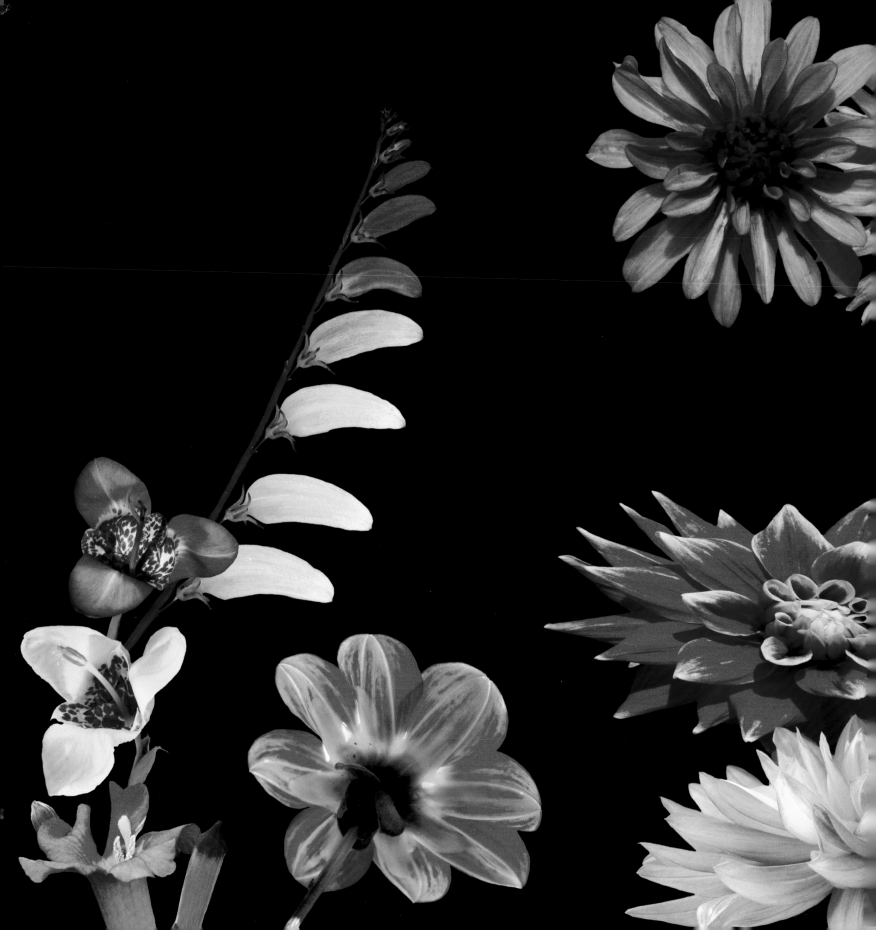

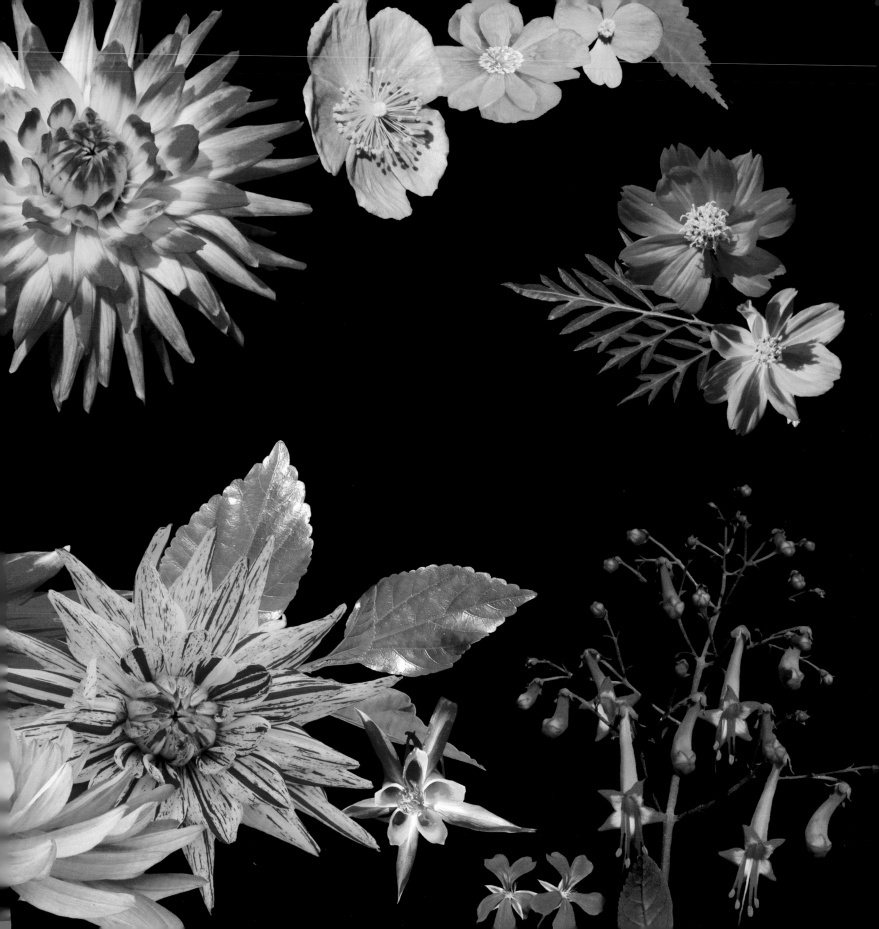

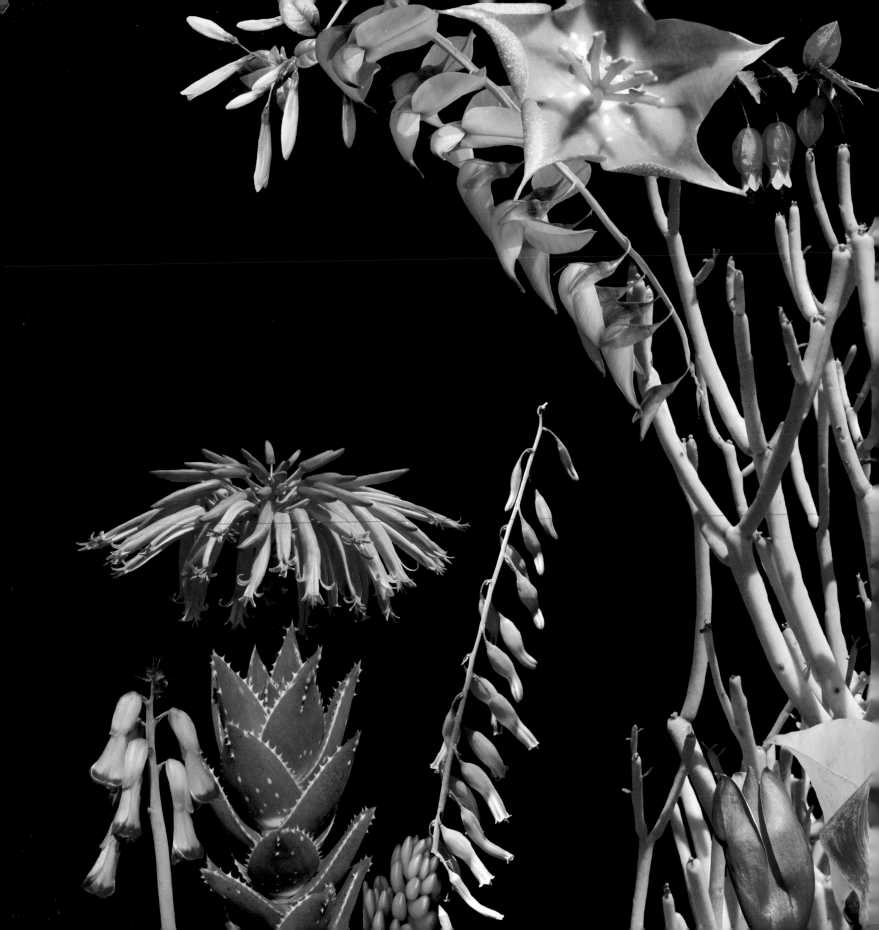

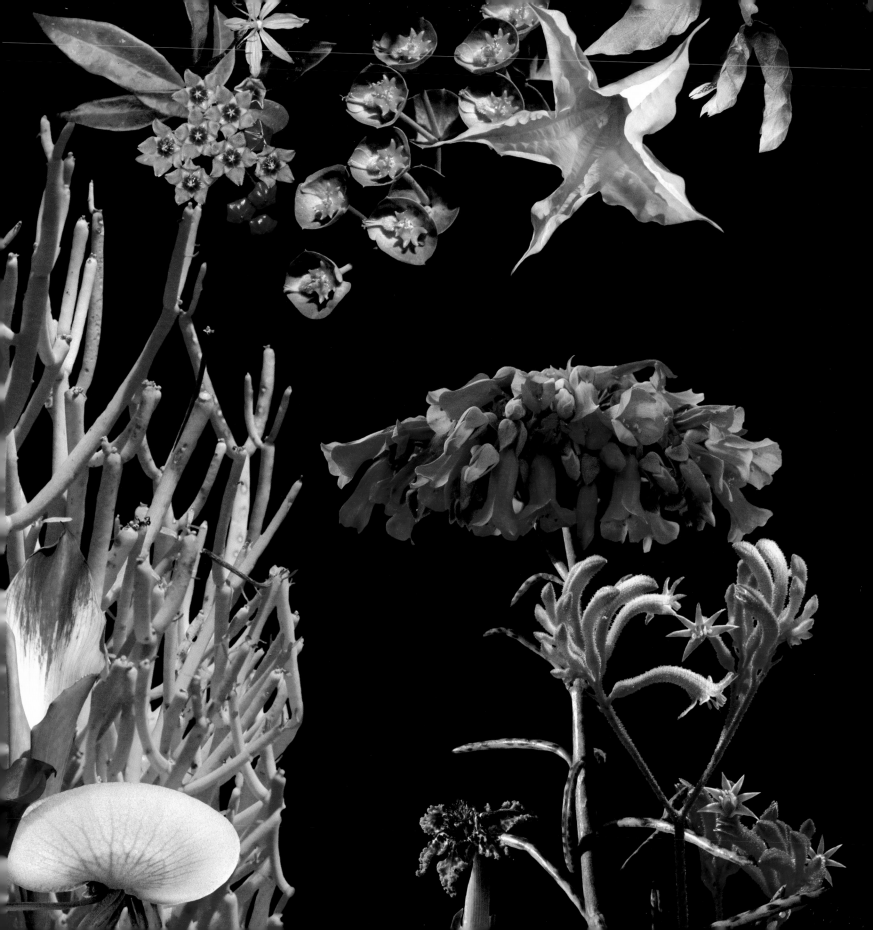

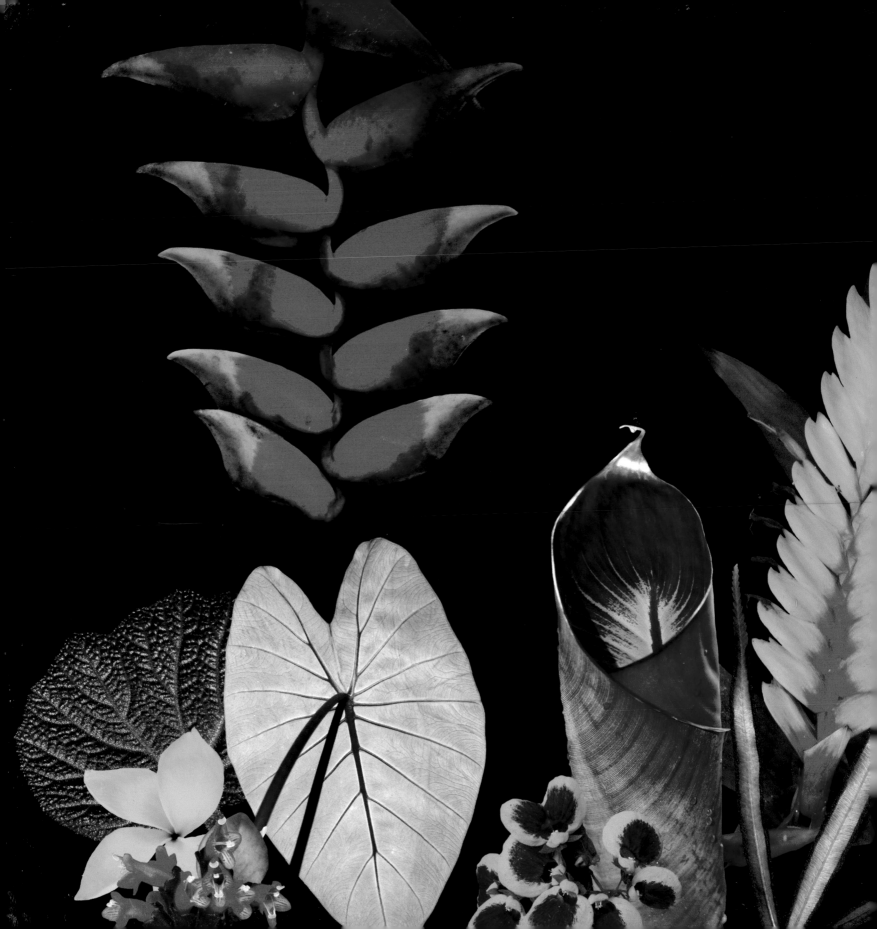

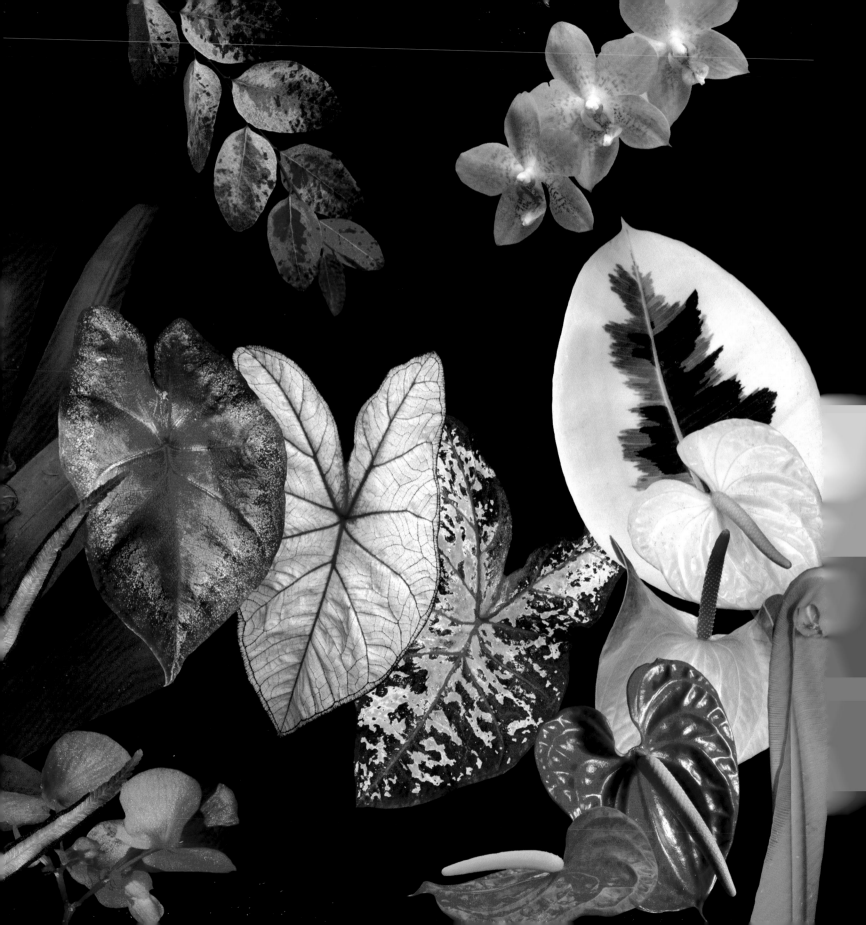

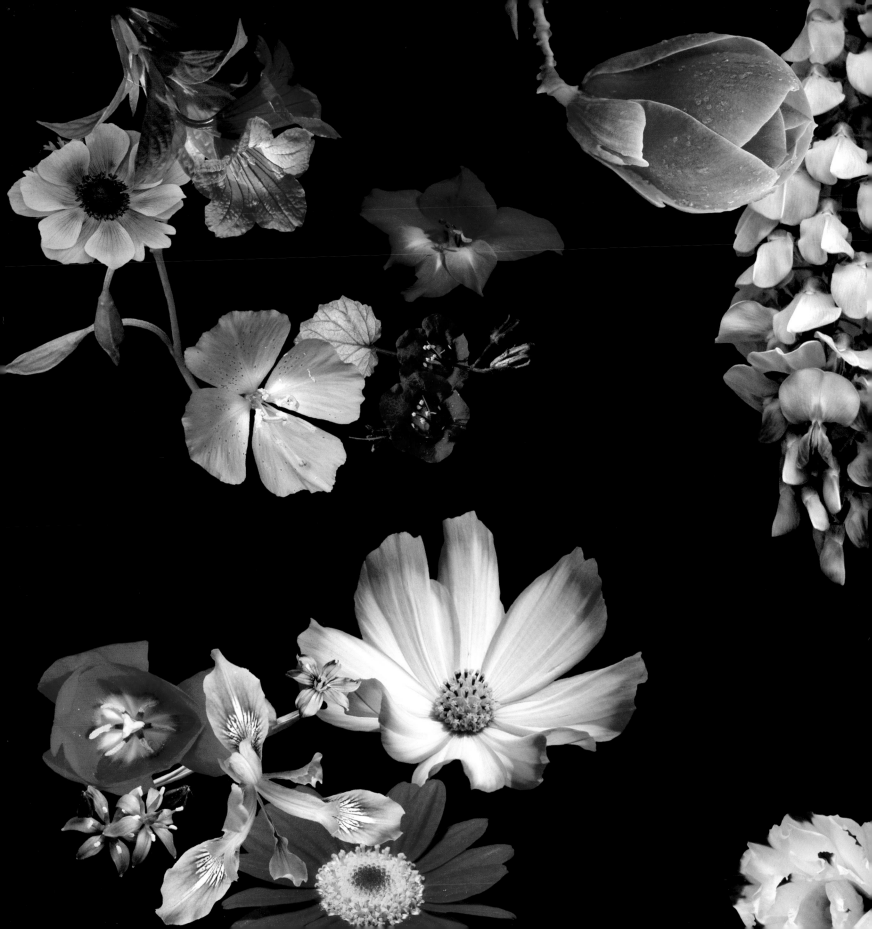

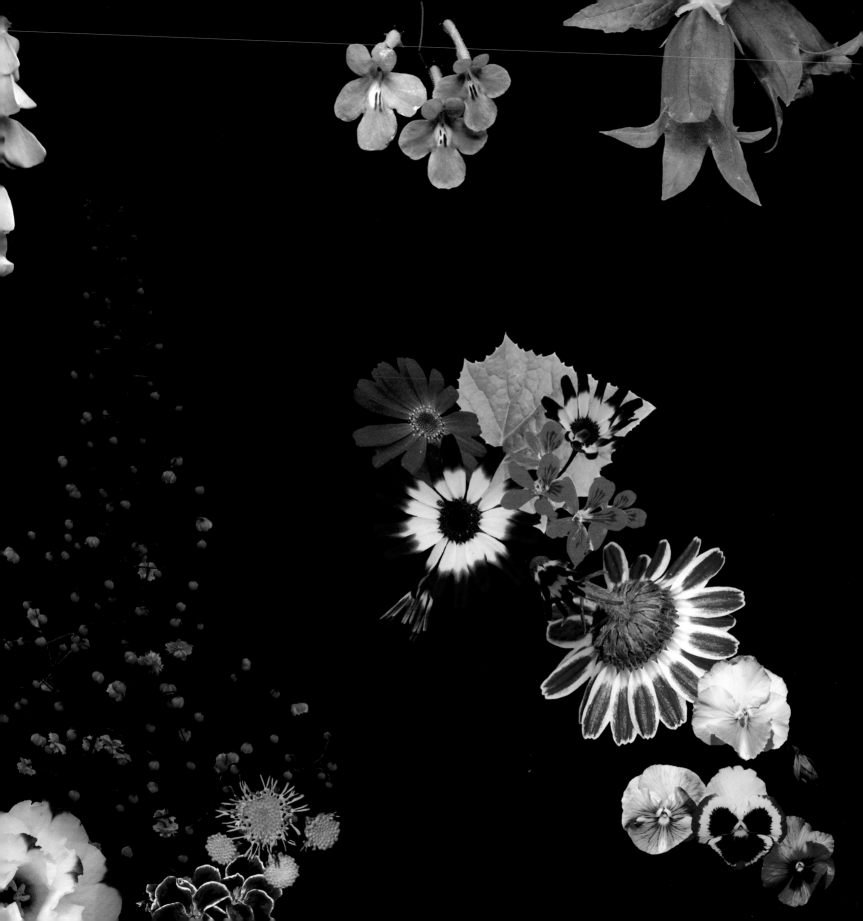

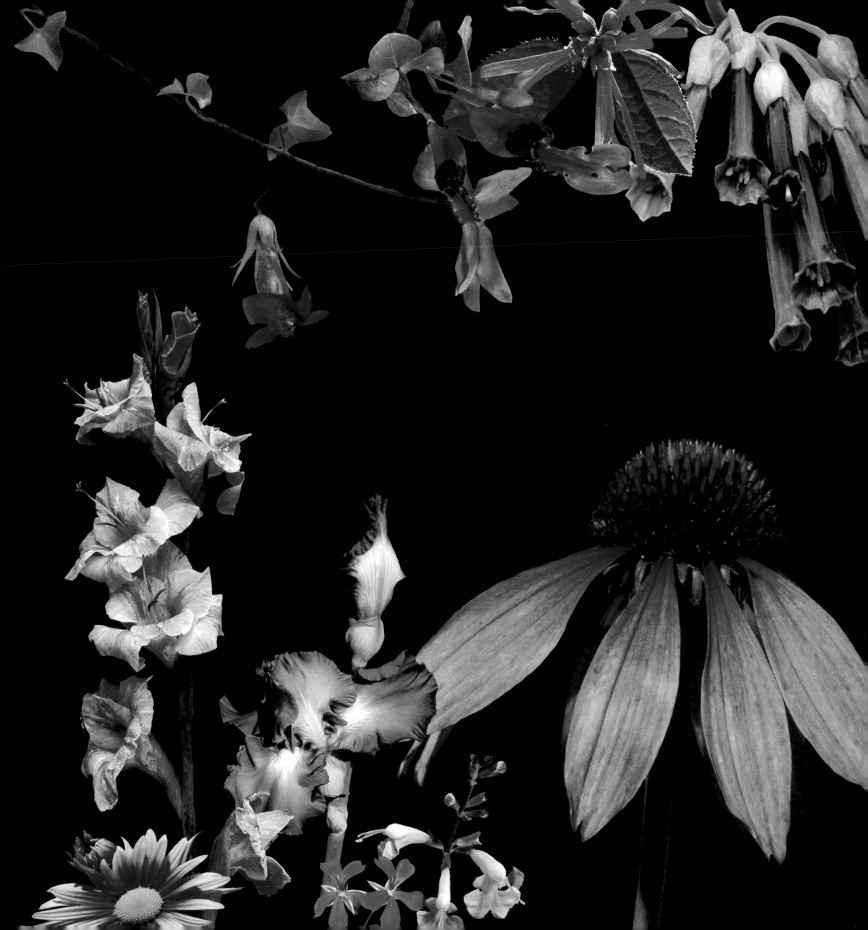

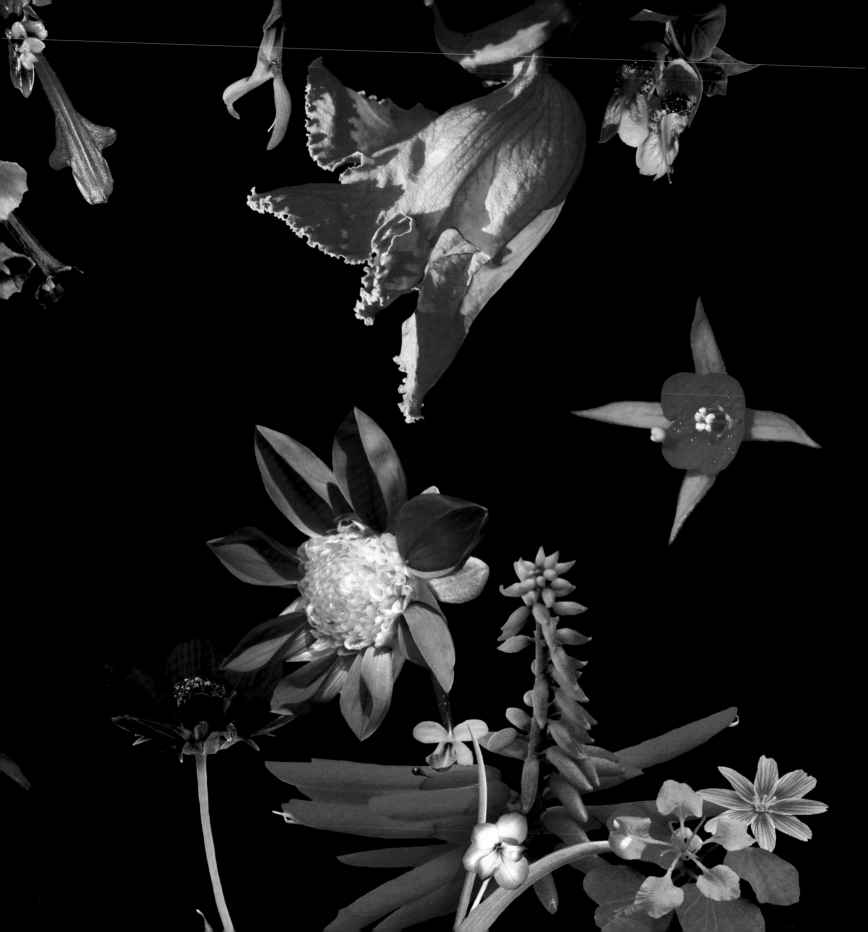

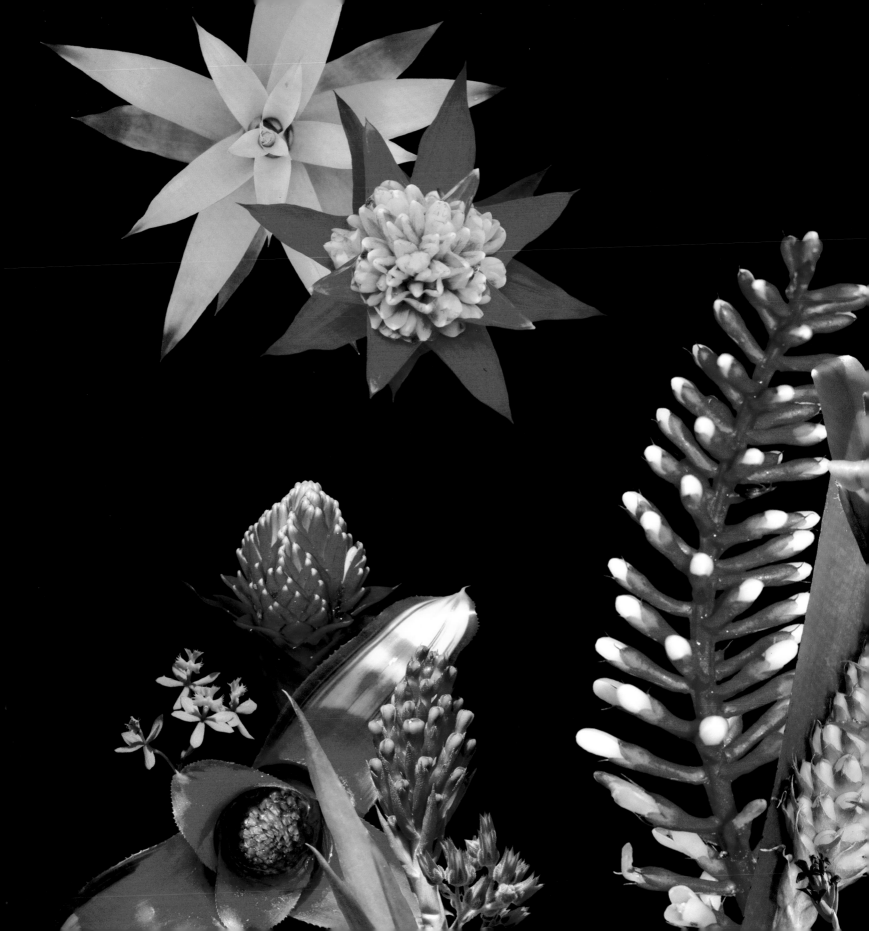

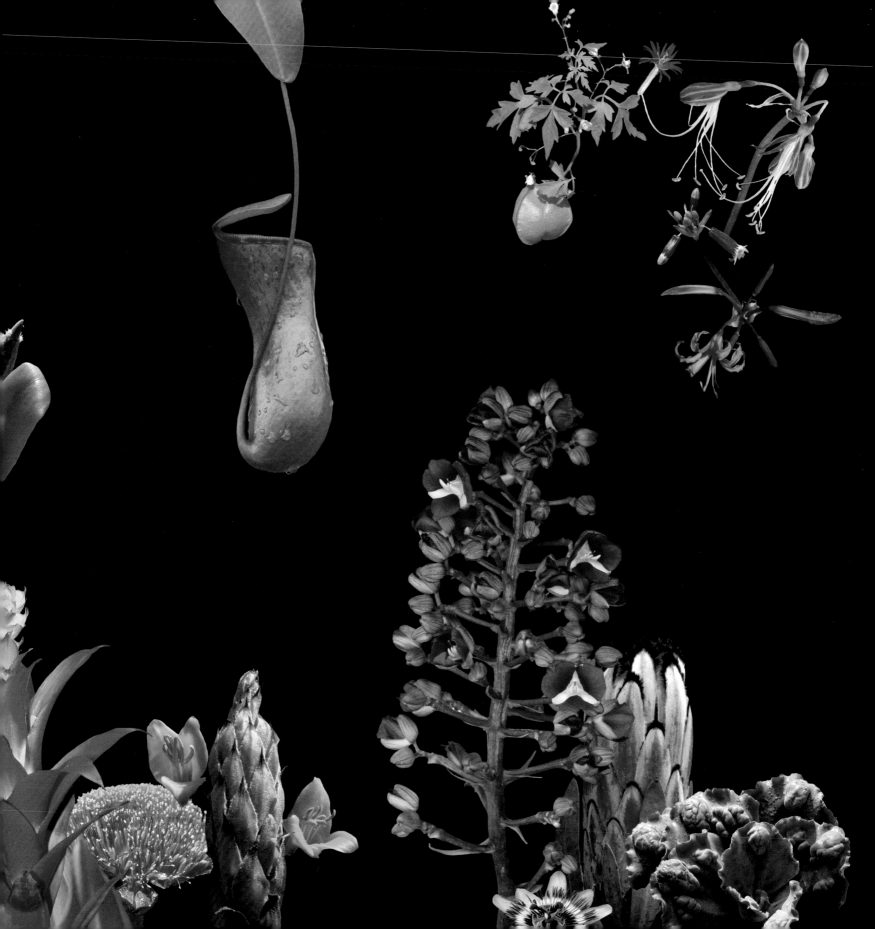

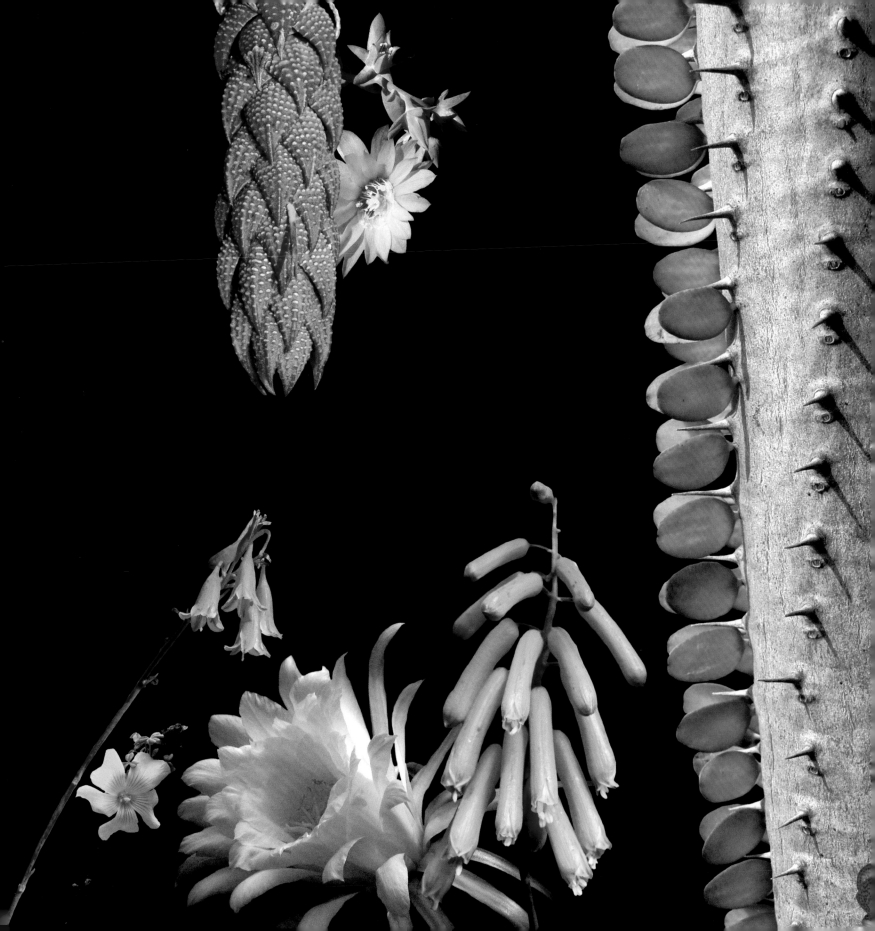

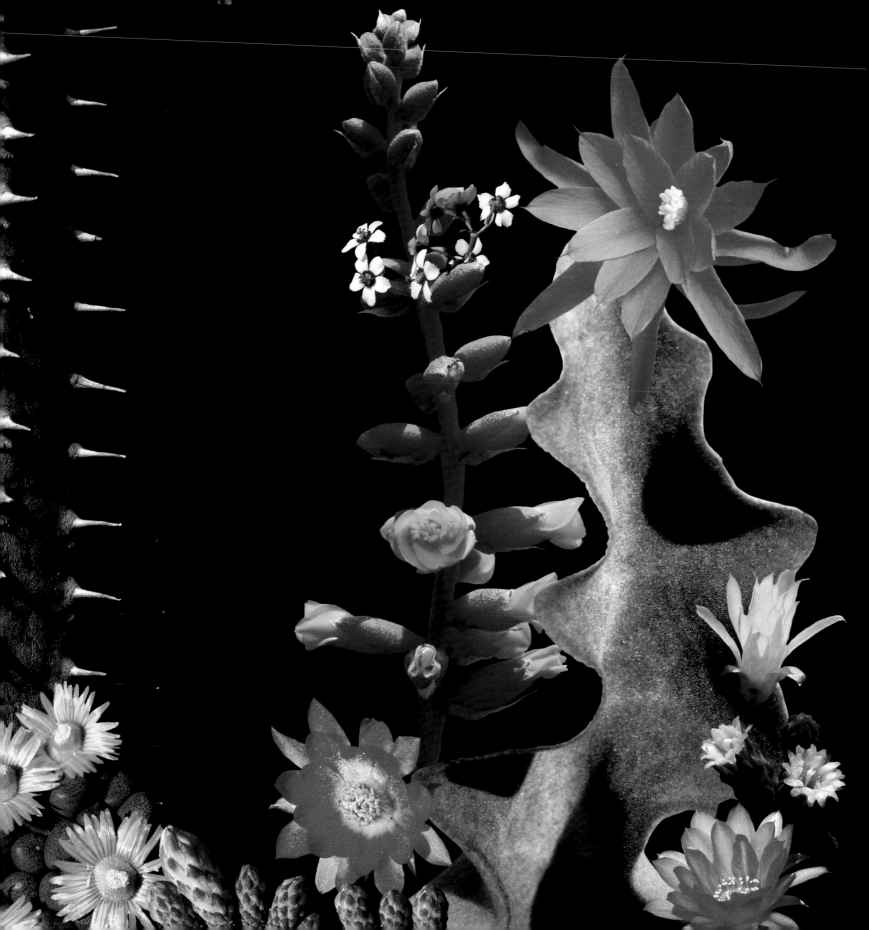

Index

1. Rosa 'Altissimo' - Asia, Europe, N. Africa, N. America 2. Rosa 'Westerland' - Same as no. one 3. Zante-deschia elliottiana - Origin unknown 4. Tulipa hybrid - Europe, Asia, Middle East 5. Sandersonia aurantiaca - South Africa 6. Crocosmia crocosmiiflora - South Africa 7. Antirrhinum majus - Europe, United States, N. Africa

1. Penstemon centranithifolius - California, Baja California 2. Dahlia 'Gitts Respect' - Central America 3. Arctotis fastuosa - S. Africa 4. Gazania Chansonete series - Africa 5. Lobelia hybrid 'Will Scarlet' - N., Central & S. America 6. Kalanchoe blossfeldiana - Madagascar 7. Same as no. four 8. Lotus maculatus - Cape Verde & Canary Islands 9. Anomatheca laxa - Southern Africa, Mozambique 10. Geranium frutoreum - Worldwide 11. Gladioli cultivar - Africa, Asia, Mediterranean, Arabian peninsula 12. Same as no. two 13. Mimulus punicens - California, Mexico 14-15. Mimulus aurantiacus - Oregon, California 16. Same as no. two 17. Ranunculus asiaticus - Mediterranean, Africa, S. W. Asia 18. Freesia hybrid - S. Africa

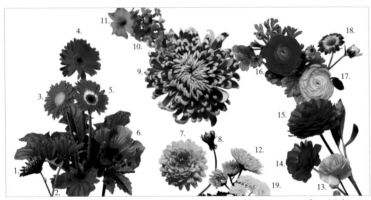

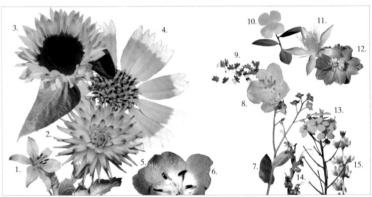

1-2. Chrysantheum cultivar - Artic, Russia, China, Japan 3-5. Gerbera jamesonii - Africa, Madagascar, Asia, Indonesia 6. Hibiscus acetosella - Africa 7. Same as no. one 8. Taraxacum officinale - N. America 9. Same as no. one 10. Kalanchoe blossfeldiana - Madagascar 11. Thunbergia gregorii - Africa 12. Same as no. one 13-17. Ranunculus asiaticus - Mediterranean, Africa, S.W. Asia 18. Same as no. one 19. Same as no. three

1. Lilium x hybrida - Europe, Asia, S. America 2. Dahlia cultivar - Central America 3. Helianthus annus - N., S. & Central America 4. Layia platyglossa - W. United States 5. Taraxacum officinale - California 6. Nemophila meniesii - California, Nevada 7. Myosotis sylvatica - Europe, Asia, Australia, N. & S. America 8. Fremontodendron 'California Glory' - California 9. Nemesia strumosa - Southern Africa 10. Dendromecon harfordii - Mexico, California 11. Mentzelia laevicaulis - W. United States 12. Delphinium hybrid - Worldwide 13. Erysimum capitatum - California 14. Trichostema parishii - California, Baja California 15. Lupinus densiflorus - California

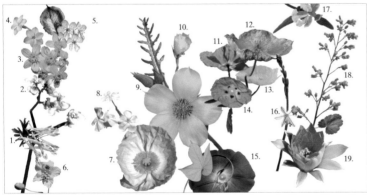

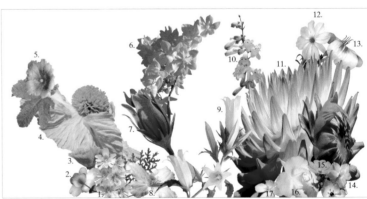

1. Corydalis flexuosa - China 2. Begonia cultivar - Worldwide 3. Eriophyllum confertiflorum - Western North America 4. Ipheion uniflorum - Argentina 5. Pyrus kawaksami - Europe, Asia, N. Africa 6. Parkinsonian aculeta - Mexico 7. Papaver croceum - Subartic regions 8. Plumbago auriculata - Worldwide 9-10. Mentzelia lindleyi - California 11-13. Papaver croceum - Subartic regions 14. Cistus x purpureus - Europe 15. Ipomoea tricolor - Worldwide 16. Asphodelus fistulosus - S.W. Europe to S.W. Asia 17. Phlomis fruticosa - Mediterranean 18. Heuchera micrantha - British Columbia to Sierra Nevada 19. Echinocereus scheeri - Mexico

1. Schizanthus pinnatus - Chile 2. Begonia cultivar - Tropical & subtropical regions 3. Clarkia amoena - California 4. Romneya coulteri - Mexico, California 5. Alcea rosa - Europe, Asia 6. Yucca elephantipes - Mexcio 7. Calycanthus occidentalis - California 8. Clematis cultivar - Worldwide 9. Campanula latifolia 'Alba' - Caucasus 10. Penstemon hybrid - N. & Central America 11. Dahlia cultivar - Central America 12. Cosmos bipinnatus - Central & N. America 13. Same as no. three 14. Ornithogalum arabicum - Mediterranean 15. Primula hybrid - Worldwide 16. Rosa 'Sombreuil' - Asia, Europe, N. Africa, N.America 17. Eschscholzia californica - Oregon, California

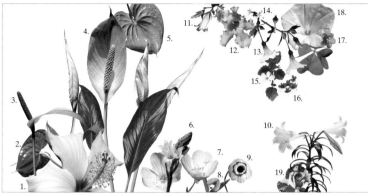

1. Hibiscus rosa-sinensis - Origin unknown 2-5. Anthurium andraeanum - North & South America 6. Lillium hybrid - Europe, Asia, North America 7. Oenothera speciosa - Mexico 8. Lathyrus laetiflorus - Temperate regions 9. Anenome coronaris - Mediterranean 10. Same as no. six 11. Campanula latifolia - Europe, Caucasus, Turkey, Iran, W. Asia to India 12. x Chitalpa tashkentensis - Uzbekistan 13. Nolana paradoxa - Peru, Chile 14. Pelargonium cultivar - S. Africa 15. Bacopa 'Snowflake' - Asia, Africa, Australia, North & South America 16. Nemesia strumosa - S. Africa 17. Oxalis tetraphylla - Mexico 18. Calystegia macrostegius - Baja California, Channel Islands 19. Rosa 'Scentimental' - Asia, Europe, N. Africa, N. America

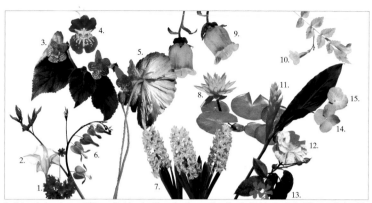

1. Primula beesiana - China 2. Mandevilla splendens - Brazil 3. Kohleria digitaliflora - Columbia 4. Miltoniopsis hybrid - S. & Central America 5. Papaver croceum - Subartic regions 6. Dicentra spectablis - Siberia, Korea, China 7. Hyacinthus orientalis - Asia 8. Nelumbo nucifera - Asia, Australia, N. America 9. Campanula species - Europe, Turkey, N. Hemisphere 10. Incarvillea arguta - Himalayas, China 11. Alpina nutans - India, China, S.E. Asia, Australia 12. Rosa 'Peaches & Cream' - Asia, Europe, N. Africa, N. America 13. Pelargonium 'Mosaic' - S. Africa 14-15. Hydrangea macrophylla - Japan

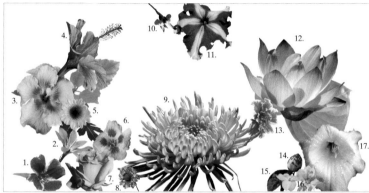

1. Clarkia amoena - California 2. Habranthrus robustus - Brazil 3-4. Hibiscus rosa-sinenisi - Origin unknown 5. Chrysanthemum cultivar - Mediterranean 6. Same as no. one 7. Rosa 'Pearly Gates' - Asia, Europe, N. Africa, North America 8. Scabiosa atropurpurea - Europe 9. Chrysanthemum cultivar 10. Salvia 'Hot Lips' - California 11. Petunia Ultra Series - America 12. Nelumbo nucifera - Asia, Australia, N. America 13. Rhododendron cultivar - Europe, Asia, Australasia, N. America 14. Camelia japonica - China, Korea, Japan 15. Impatiens oliveri - East Africa 16. Pelargonium cultivar - S. Africa 17. Datura discolor - Arizona, California, Mexico, West Indies

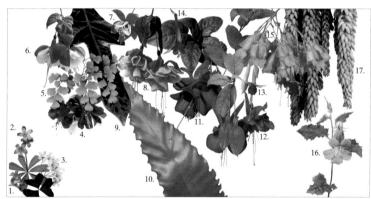

1. Oxalis species - Africa, S. America 2. Oxalis lasiandra - Mexico 3. Oxalis regnellii - S. America 4. Fuchsia cultivar - South & Central America, New Zealand 5. Asplenium trichomanes - Temperate regions 6-8. Same as no. four 9. Codiaeum variegatum - Malaysia, E. Pacific 10. Asplenium scolopendrium - Europe, Asia, N. America 11-14. Same as no. four 15. Begonia cultivar - Worldwide 16. Rehamannia elata - China 17. Sedum morganianum - Mexico

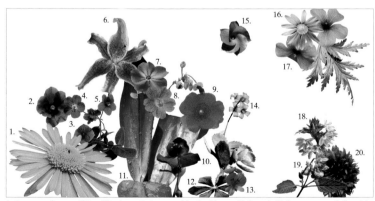

1. Aster tongolenses - China, Himalayas 2. Anemone blanda - Europe, Turkey 3. Hydrangea macrophylla - Asia, N. & S. America 4. Geranium 'Brookside' - Worldwide 5. Viola odorata - Europe 6. Lilium 'Star Gazer' - Europe, Asia, S. America 7. Impatiens walleriana - Worldwide 8. Geranium incanum - S. Africa 9. Calandrinia grandiflora - Chile 10. Tradescantia x. andersoniana - N., Central, & S. America 11. Cordyline fruticosa - S.E. Asia 12. Clematis cultivar - Worldwide 13. Pelargonium cultivar - S. Africa 14. Kalanchoe pumila - Madagascar 15. Alogyne huegelii - Australia 16. Felicia amelloides - S. Africa 17. Geranium madrense - Madeira 18. Scaveola amuela - Australia 19. Salvia melissodora - Worldwide 20. Centaurea cyanus - Europe, Mediterranean

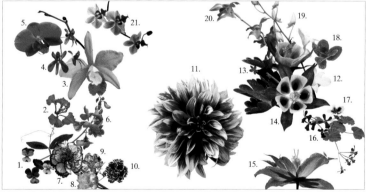

1.Viola tricolor - Europe, Asia 2. Clarkia unguiculata - California 3. Cattleya 'Alliance' - India, S.W. Asia, Australia 4. Dendrobium hybrid - India, S.E. Asia, Australia, Pacific Islands 5. Phalaenopsis hybrid - Himalayas, S.E. Asia, Australia 6. Lathyrus latifolius - Europe 7-10. Dianthus cultivar - Europe, Asia, North America 11. Dahlia 'Conrast' - Central America 12. Same as no. four 13. Talinum calycinum - Western USA 14. Aquileglia hybrid - Northern Hemisphere 15. Clematis hybrid - Europe, China, Australasia, N. & S. America 16. Pelargonium sidoiedes - S. Africa 17. Pelargonium 'Michael' - S. Africa 18. Same as no. five 19-21. Same as no. four

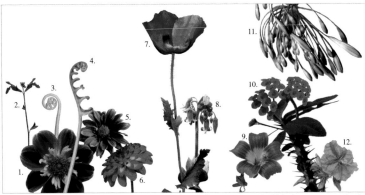

1. Dahlia 'Awaikoe' - Central America 2. Salvia blepharephylla - Mexico 3-4. Phlebodium aureum - Florida, Mexico, W. Indies, Central & S. America 5. Chrysanthemum cultivar - Mediterranean 6. Dahlia cultivar - Central America 7. Papaver oriental - Caucasus, Turkey, Iran 8. Cotyledon species - Africa, Arabian peninsula 9. Lavatera assurgentiflora - California, Santa Catalina Island 10. Euphorbia milii - Madagascar 11. Agapanthus africanus - Africa 12. Solanum hindsianum - N. America, Mexico

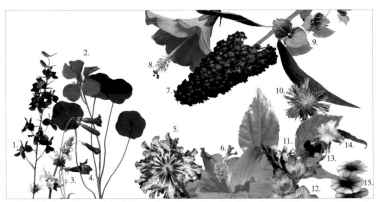

1. Consolida ajacis - Europe, Asia 2. Tropaeolum majus - Central & S. America 3. Gilia capitata - N. America 4. Penstemon 'Ghent Purple' - N. & Central America 5. Scabiosa columbaria - Europe, W. Asia 6. Hibiscus rosa-sinensis - Origin unknown 7. Buddleia davidii - Asia, Africa, N. & S. America 8. Same as no. six 9. Dalechampia discoreifolia - S. America 10. Stokesia laevis - S.W. United States 11. Pelargonium pelatum - S. Africa 12. Freesia cultivar - S. Africa 13. Thunbergia grandiflora - N. India 14. Chilopsis linearis - Mexico, S.W. United States 15. Petunia cultivar - S. America

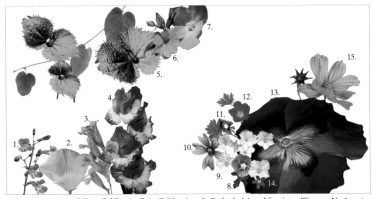

1. Penstemon spectabilis - California, Baja California 2. Eschscholzia californica - Western N. America 3. Penstemon heterophyllus - Central America 4. Gladiolius cultivar - Africa, W. Asia, Arabian peninsula 5. Dalechampia discoreifolia - S. America 6. Impatiens 'New Guinea Group' - Tropical, Temperate regions 7. Begonia species - Tropical & Subtropical regions 8. Anisodenata x. hypomadarum - Garden origin 9. Nierembergia repens - S. America 10. Geranium robertianum - Europe, Canary Islands, Africa, Asia, China 11. Pelargonium 'Fairy Cascade' - S. Africa 12. Callirhoe involucrata - USA 13. Papaver oriental - Caucasus, Turkey, Iran 14. Centarium venustrium genetia - California 15. Cosmos bipinnatus - United States, S. America

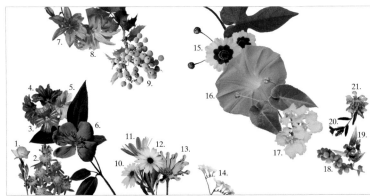

1. Hunnemannia fumariifolia - Mexico 2. Senecio confusus - Mexico to Honduras 3-5. Salpigossis sinuata - Peru, Argentina 6. Tibouchia urvilleana - S. America 7-8. Hemerocallis hybrid - China, Korea, Japan 9. Mahonia aquifolium - W. North America 10. Gazania hybrid - Africa 11-13. Osteopermum cultivar - Africa, Arabia 14. Freesia cultivar - Africa 15. Gaillardia pulchella - United States, Mexico 16. Ipomoea tricolor - Central & S. America 17. Stigmaphyllon ciliatum - Belize to Uruguay 18. Symphoricarpos x. doorenbosii - Garden origin 19. Angelonia agustifolia - Central & S. America 20. Lithospermum purpurocaerulea - Europe, Russia, Asia 21. Lamium maculatum - Europe, N. Africa, W. Asia

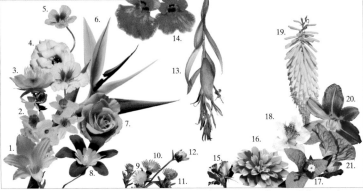

1. Zephyranthes grandiflora - Central America 2. Narcissus cultivar - Europe, Africa 3. Trollius x. cultorum - Europe, Asia, N. America 4. Eustoma grandiflorum - N. & S. America 5. Tropaeolum majus - Central & S. America 6. Strelitzia reginae - S. Africa 7. Rosa 'Sterling Silver' - Asia, Europe, N. Africa, N. America 8. Sparaxis tricolor - S. Africa 9-11. Lampranthus aurantiacus - S. Africa 12. Chrysanthemum cultivar - Russia, China, Japan, Arctic 13. Billbergia nutans - S. America 14. Mimulus x. hybridus - Africa, Asia, Australia, N., Central & S. America 15. Rosa 'Leanidas' - Europe, Asia, N. Africa, N. America 16. Dahlia cultivar - Central America 17. Bougainvillea x. buttiana - Garden origin 18. Rhododendron hybrid - Worldwide 19. Kniphofia 'Bees' Sunset' - Africa 20. Hermocallis hybrid - China, Korea, Japan 21. Abutilon x. hybridum - Africa, Asia, Australia, N. & S. America

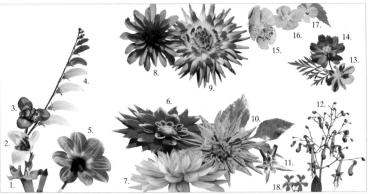

1. Disticis buccinatoria - Mexico 2-3. Tigridia pavonia - Mexico 4. Ipomoea lobata - Mexico, Central & S. America 5. Dahlia 'Caboose' - Central America 6-10. Dahlia cultivar - Central America 11. Aquilea formosa - California, Nevada 12. Phygelius x rectus - South Africa 13-14. Cosmos sulfureus - Mexico 15. Helianthemum hybrid - Europe, N. & S. America 16. Papaver rupifragum - Spain 17. Begonia sutherlandii - Africa, Tanzania 18. Pelargonium 'Mutzel' - S. Africa

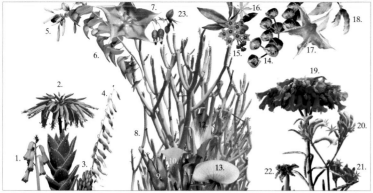

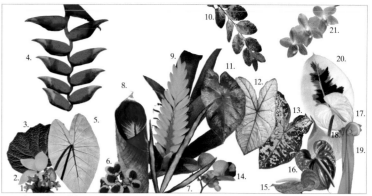

1. Lachenalia aloides quadricolor - S. Africa 2. Aloe glauca - Cape of Good Hope 3. Sedum species - Northern hemisphere 4. Gasteria verrucosa - S. Africa 5. Justicia rizzinii - Brazil 6. Crotalaria agatiflora - E. Africa 7. Volunteer - Origin unknown 8. Euphorbia tiracalli - Africa 9. Magnolia x soulangeana - Garden origin 10-11. Zantedeschia elliottiana hybrid - Origin unknown 12. Zantedeschia aethiopica - Africa 13. Platycerium bifurcatum - Java to E. Australia 14. Euphorbia crenulata - S.W. United States 15. Hoya carnosa - India, Burma, China 16. Asphodeline lutea - Mediterranean, Turkey 17. Brugmansia x candida - Garden origin 18. Justica brandeyeeana - Mexico 19. Kalanchoe tubiflora - Madagascar 20-21. Angiothanus flavius - Australia 22. Ferraria crispa - S. Africa 23. Ablution megapotamicum - Brazil

1. Aeschynanthus pulcher - Indonesia 2. Plumeria rubra - Mexico, Panama 3. Begonia cultivar - Worldwide 4. Heliconia bihai - Central America, W. Indies 5. Colocasia esculenta - Tropical E. Asia 6. Calceolaria herbeo hybrida - Mexico, S. & Central America 7. Pteris cretica - Europe, Asia, Africa 8. Musa velutina - India 9. Tillandsia species - USA, W. Indies, Central & S. America 10. Breynia disticha - Pacific Islands 11-13. Caladium bicolor - Garden origin 14. Same as no. three 15-17. Anthurium andraeanum - N. & S. America 18. Anthurium x. ferrierense - N. & S. America 19. Asplenium nidus - Tropical regions 20. Ficus benjamina - S.E. Asia, Australia, S.W. Pacific 21. Phalaenopsis 'Golden Leopard' - S.E. Asia, N. Australia

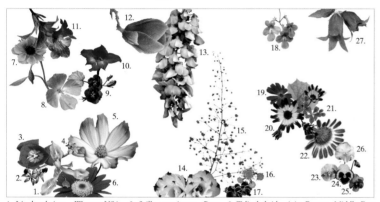

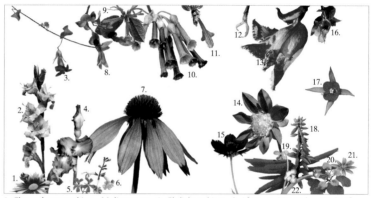

1. Iris douglasiana - Western USA 2. Scilla peruvianan - Peru 3. Tulip hybrid - Asia, Europe, Middle East 4. Sisyrinchium graminoides - N.America 5. Agrostemma githago - Mediterranean, Europe, W. Asia 6. Tanacetum coccineum - Caucasus, S.W. Asia 7. Anenome coronaris - Mediterranean 8. Clarkia amoena - California 9. Phacelia campanularia - California 10. Gladiolus hybrid - S. Africa 11. Ruella macrantha - Brazil 12. Magnolia x. soulangeana - Garden origin 13. Wisteria floribunda - Japan 14. Eustoma grandiflorum - USA, S. America 15. Thalictrum delavayi - Tibet, China 16. Ageratum houstonianum 17. Pelargonium 'Sancho Panza' - S. Africa 18. Streptocarpus 'Concord Blue' - Africa, Madagascar, China 19-20. Pericallis x hybrida - Canary Islands, Madeira, Azores 21. Pelargonium subspecies filbert - S. Africa 22. Anacyclus pyrethum - Morocco 23-26. Viola cultivar - Worldwide 27. Campanula latifolia var. marantha - Caucasus

1. Chrysanthemum cultivar - Mediterranean 2. Gladiolus cultivar - S. Africa 3. Maurandya antirrhiniflora - S.W. USA, Mexico 4. Iris hybrid - Northern hemisphere 5. Pelargonium 'Mutzel' - S. Africa 6. Salvia greggii - Texas, Mexico 7. Echinacea purpurea - N. America 8. Ruttya fruiticosa - S. Africa 9. Loropetalum chinense v. rubrum - Himalayas, China, Japan 10. Iochroma cyanea - Peru 11. Aescanthynus species - Himalayas, China, Malaysia, Indonesia, New Guinea 12. Salvia guaranitica - S. America 13. Spathodea campanulata - Africa 14. Dahlia cultivar - Central America 15. Cosmos astrosanguineus - Mexico 16. Same as no. eight 17. Fuchsia 'Grand Harfare' - Central & S. America, New Zealand 18. Erythrina crista - Bolivia to Argentina 19. Clerodendrum ugandense - Africa 20. Bauhinia galpinii - Central America 21. Lewisia colytedon - N.W. California 22. Tecophila cyanocrocus leichtlinii - Chile

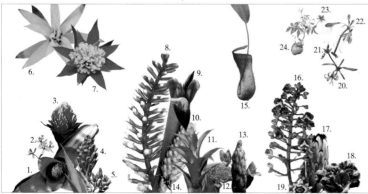

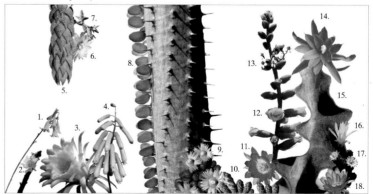

1. Neoregelia carolinae - S. America 2. Epidendrum x o'brienianum - Garden origin 3. Guzmania species - Central & S. America, W. Indies 4. Aechmea gamosepala - Brazil 5. Dudlea lanceolata - California 6. Same as no. three 7. Guzmania cardinalis - Central & S. America, Trinidad 8. Aechmea calyx - Mexico, Central & S. America 9. Puya berteroniana - Chile 10. Aechema species - S. & Central America, Mexico, W. Indies 11. Same as no. three 12. Haemanthus coccineus - S. America 13. Puya chilensis - Chile 14. Tillandsia species - USA, W. Indies, Central & S. America 15. Nepenthes ventriosa - Philippines 16. Dypsis ambositrae - Madagascar 17. Protea nerifolia - Africa 18. Echeveria species - Mexico 19. Passiflora caerula - Central & S. America 20. Nerine bowdenii - S. Africa 21. Dichelostemma ida-maia - Oregon 22. Eucrosia bicolor - Peru 23. Silene laciniata - California, Mexico 24. Cardiospermum halicacabum - Africa, India, N. & S. America

1. Kalanchoe species - Africa, Asia, Australia 2. Oxalis gigantea - Chile 3. Cereus uruguayanas - S. America 4. Aloe ciliaris - S. Africa 5. Haworthia species - S. Africa 6. Rebutia narvaecensis - Bolivia 7. Echeveria pallida - Mexico 8. Alluaudia procerr - Madagascar 9. Aloinopsis shooneesii - S. Africa 10. Pachycereus marginatus - Mexico 11. Echinocereus triglochidiatus - Mexico 12. Dyckia fosteriana - Brazil 13. Euphorbia xantii - Mexico 14. Aporocactus flagelliformis - Mexico, Central America 15. Kalanchoe beharensis - Madagascar 16. Sulcorebutia arenacea - Bolivia 17. Pachycereus marginatus - Mexico 18. Chamaecereus silvestri - Argentina